WELCOME!

GET READY AND GRAB YOUR FAVORITE COLORING TOOLS AND FEEL THE RELAXING EFFECTS OF COLORING THESE COMPLEX IMAGES THAT HAVE BEEN CREATED FOR YOU AND THE SENSE OF ACCOMPLISHMENT THAT YOU WILL GET WHEN YOU HAVE COMPLETED THEM ALL. SEE YOU AT THE END!

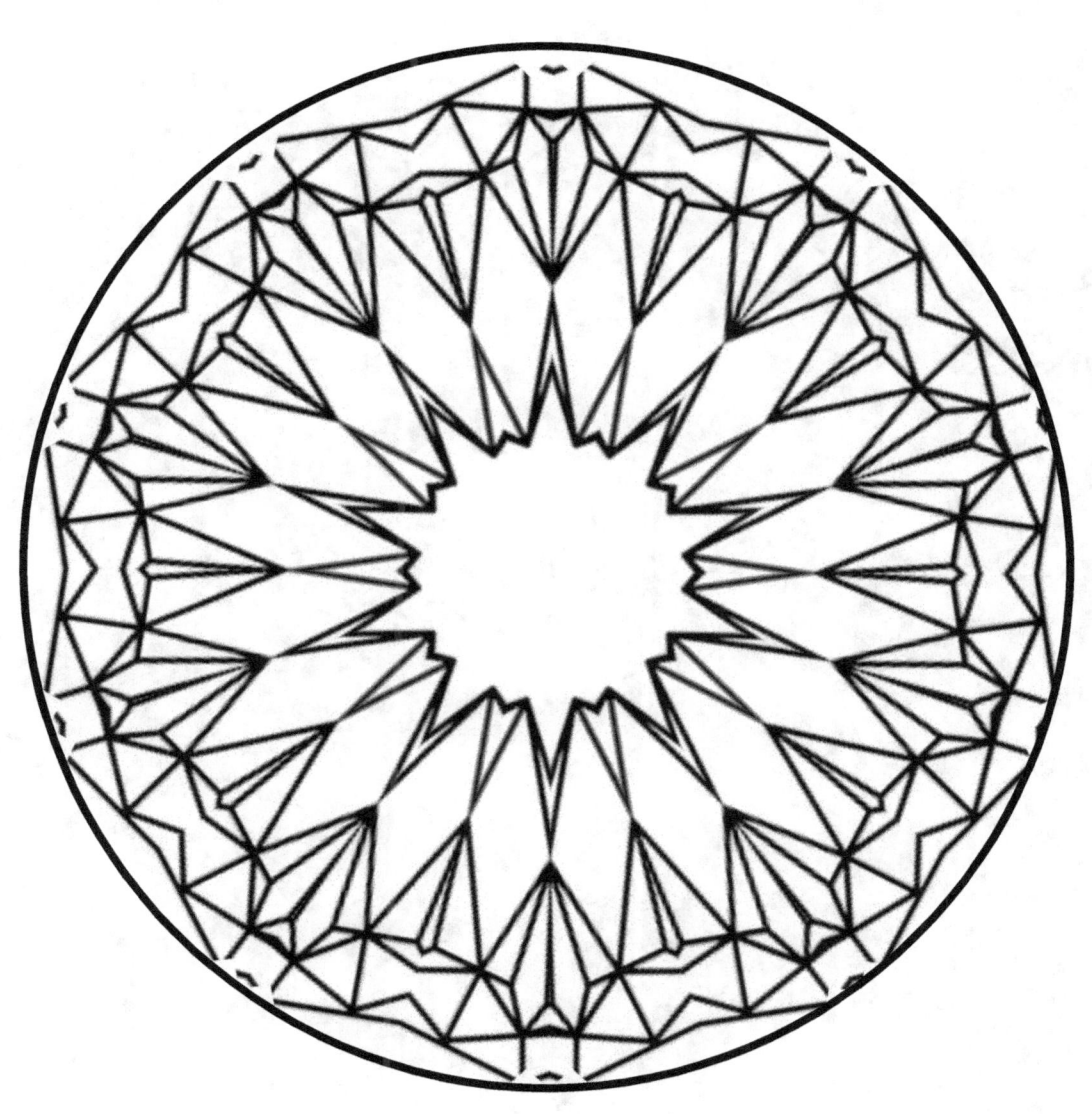

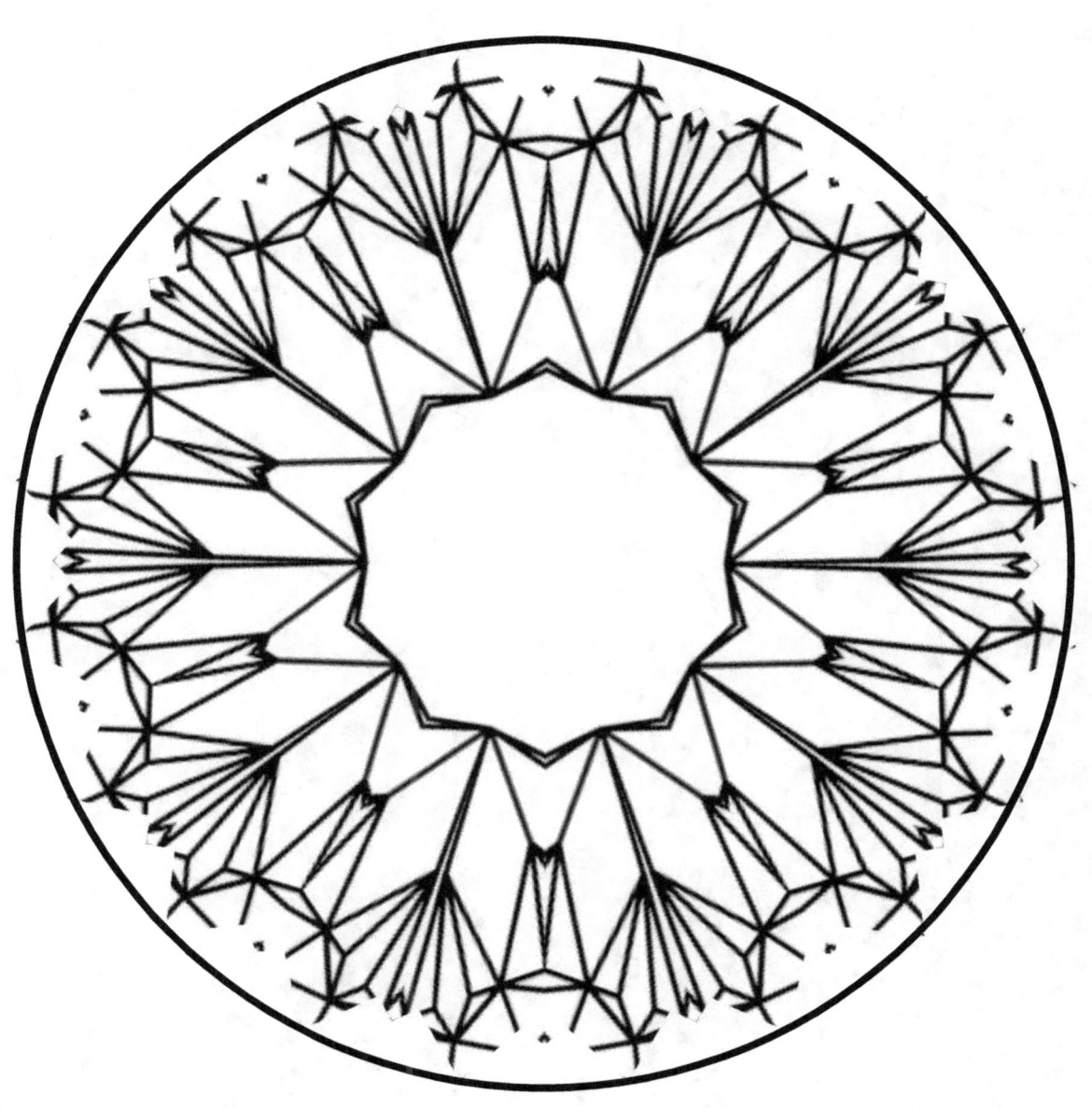

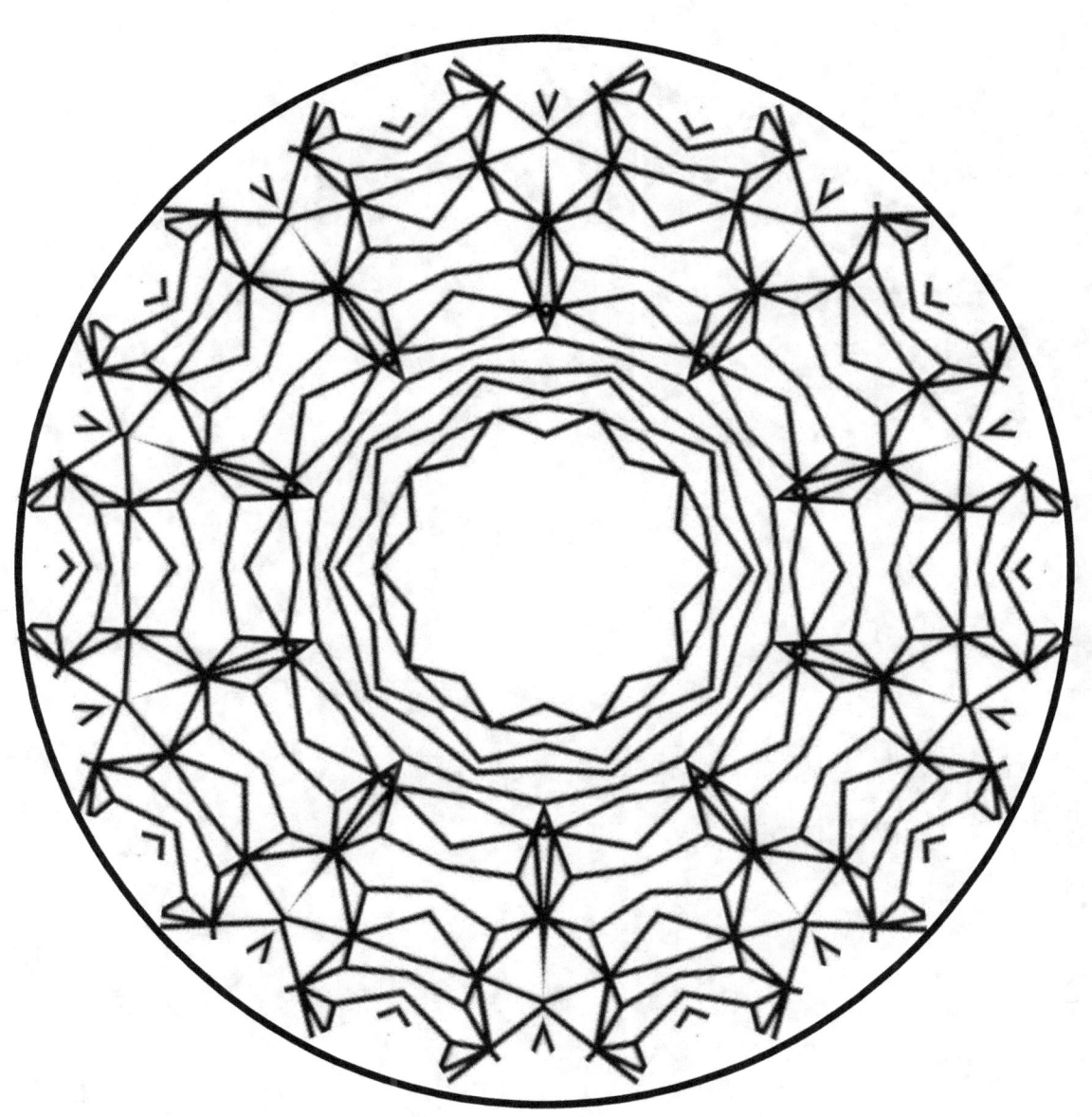

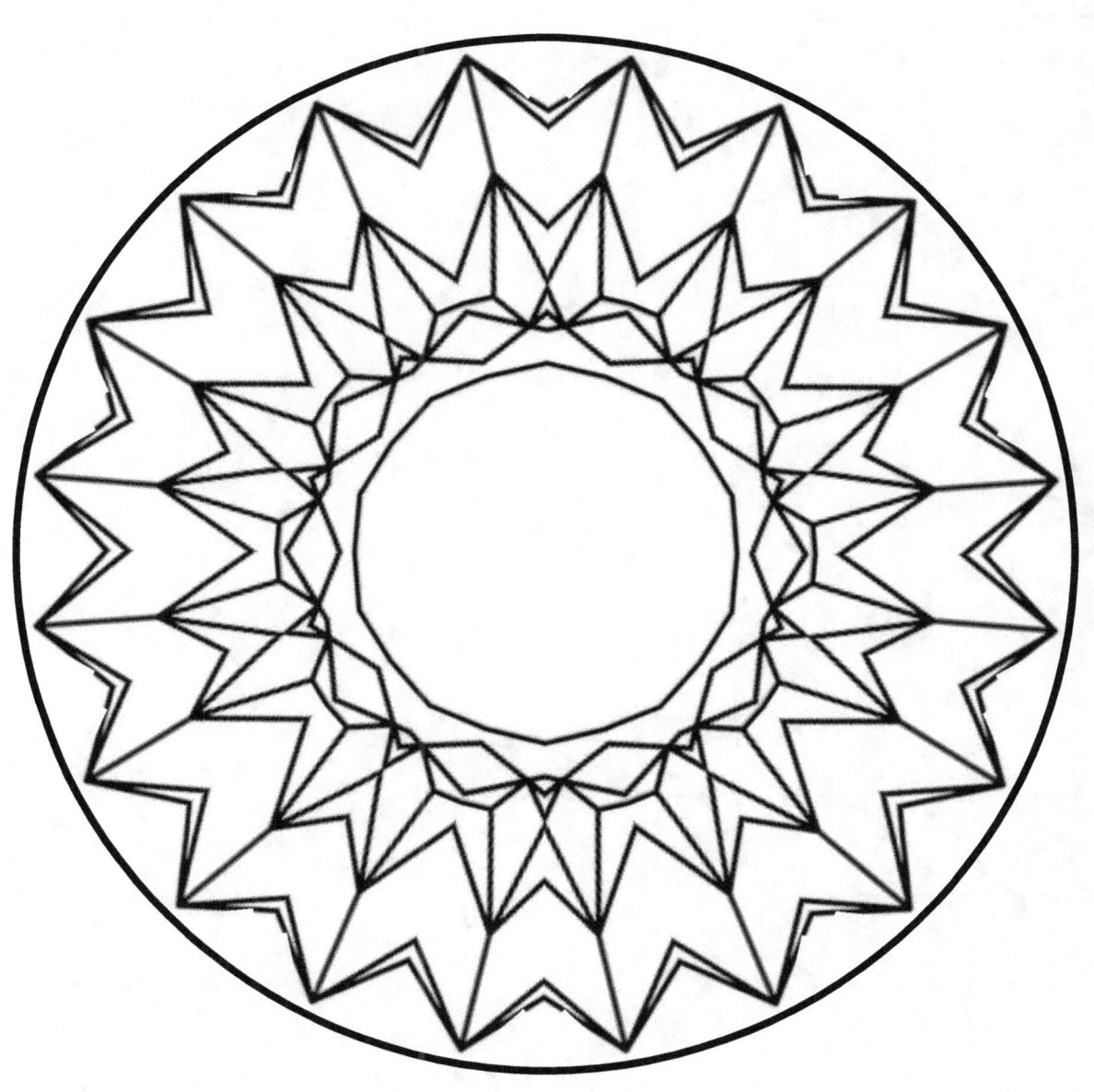

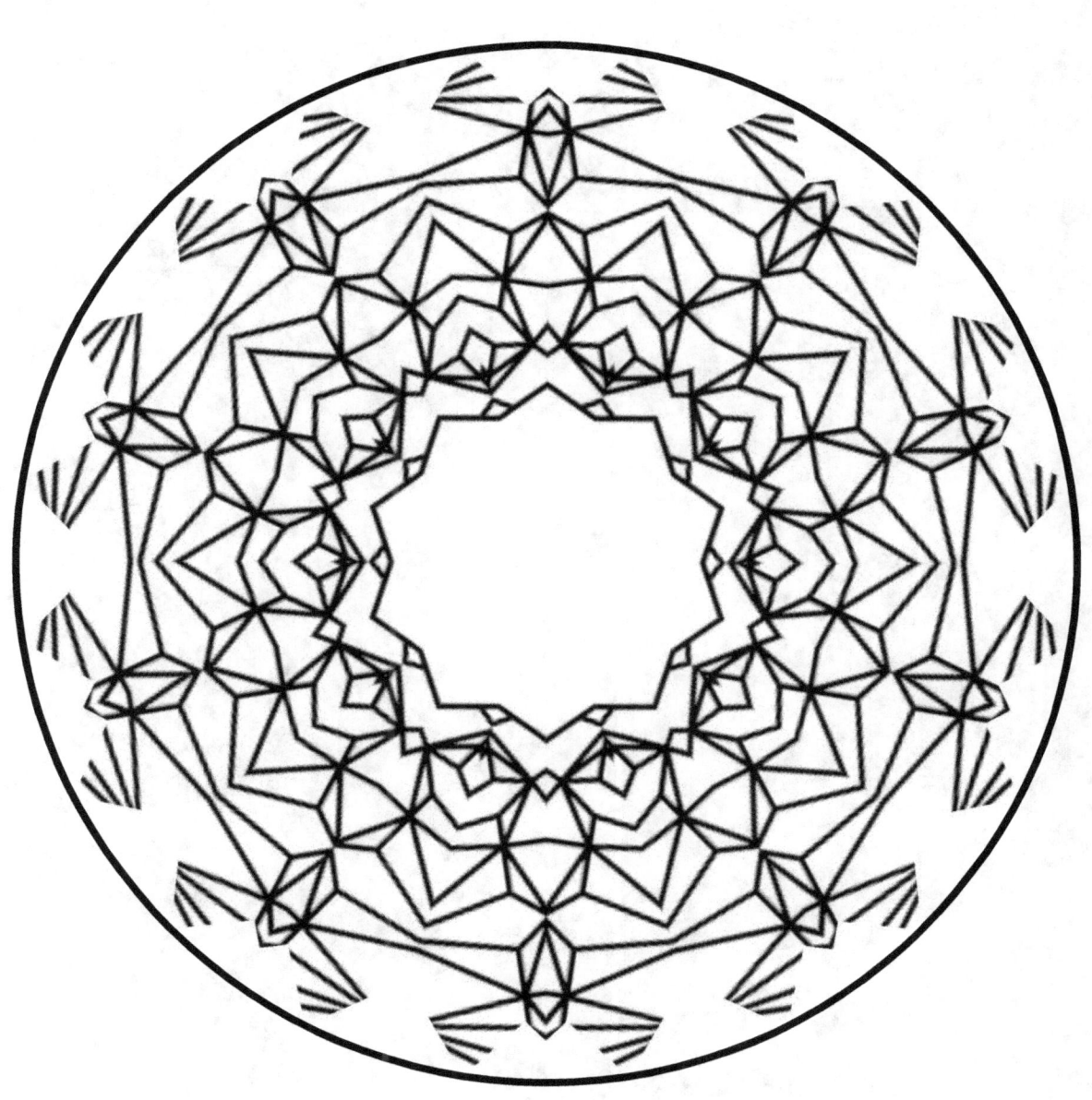

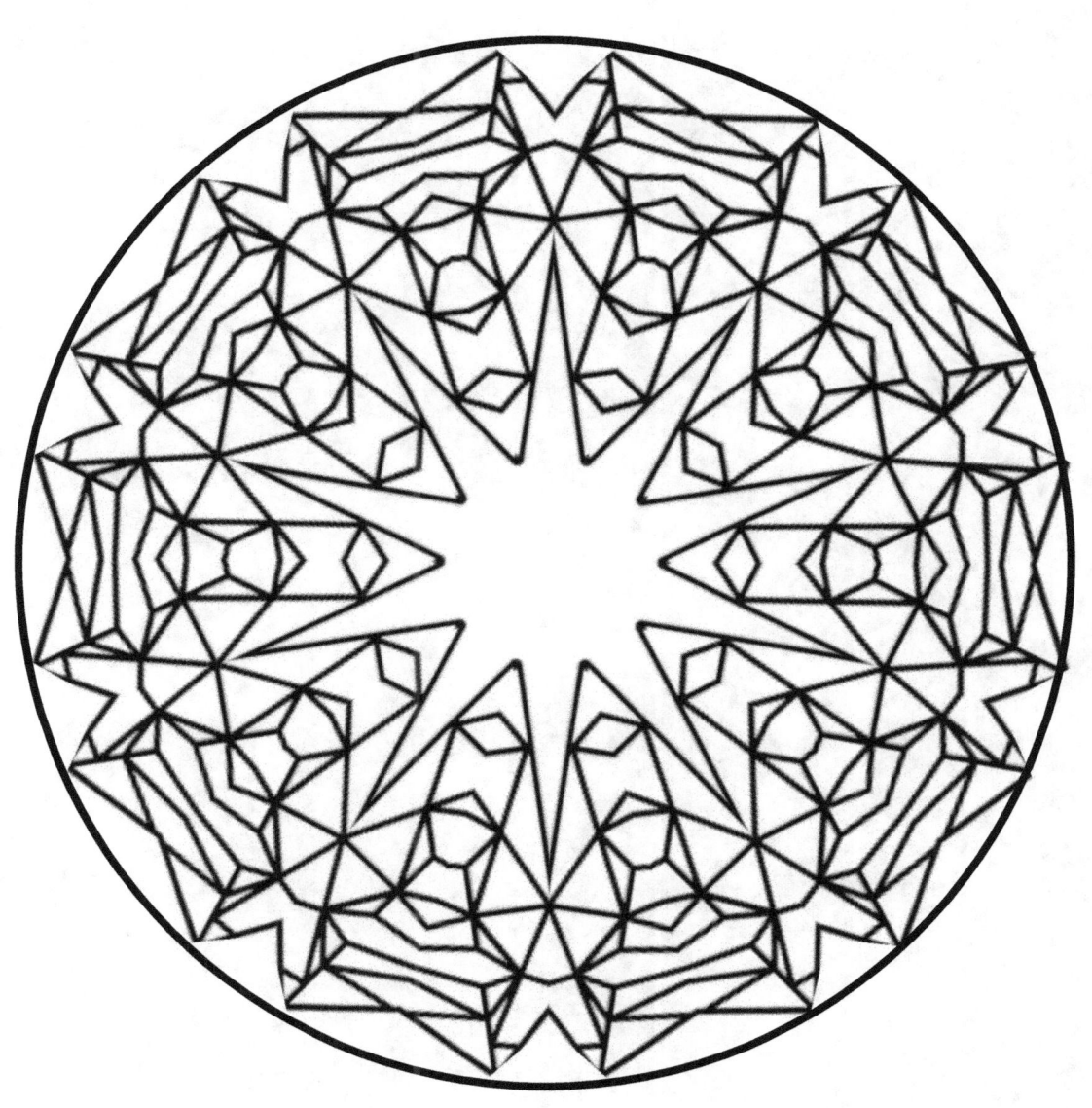

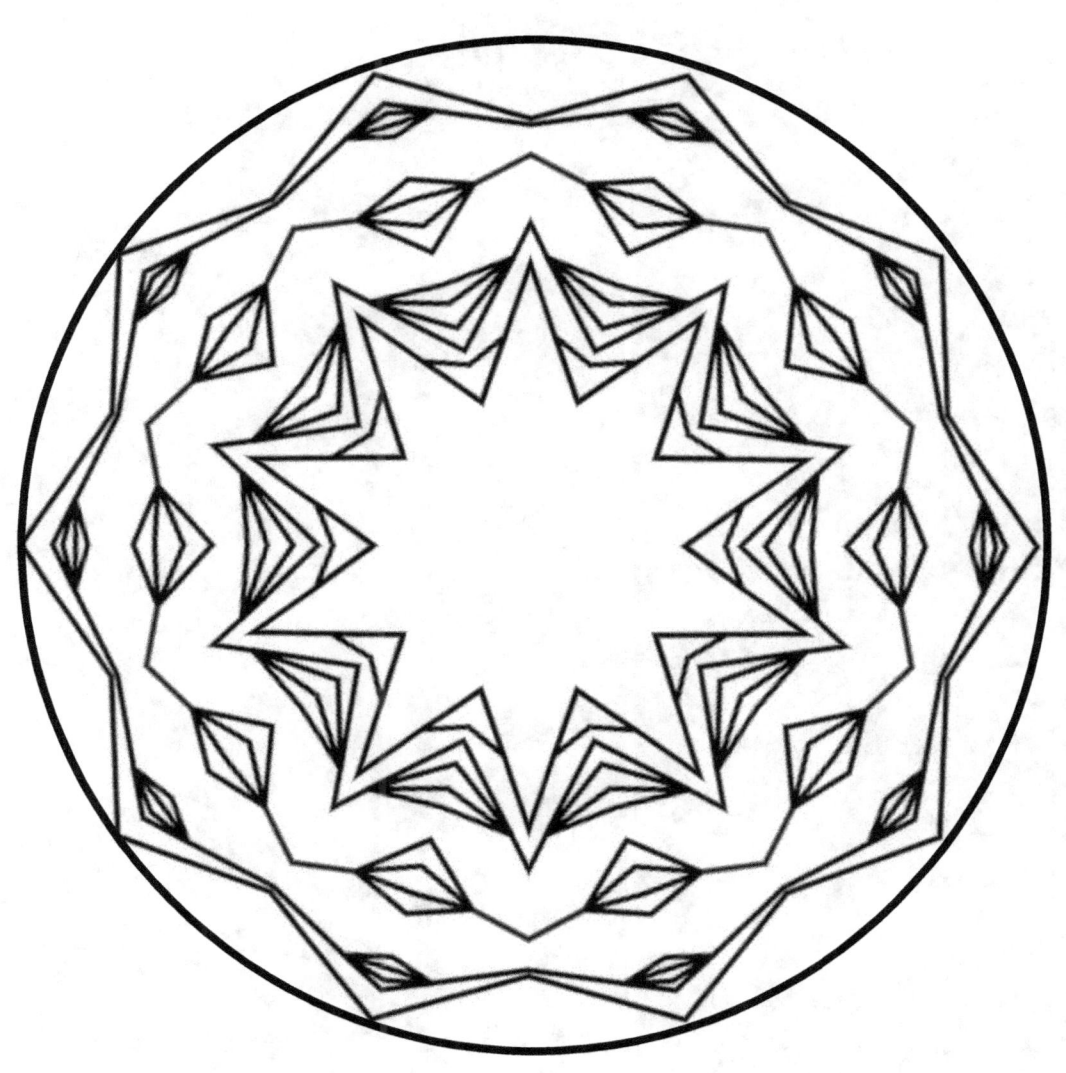

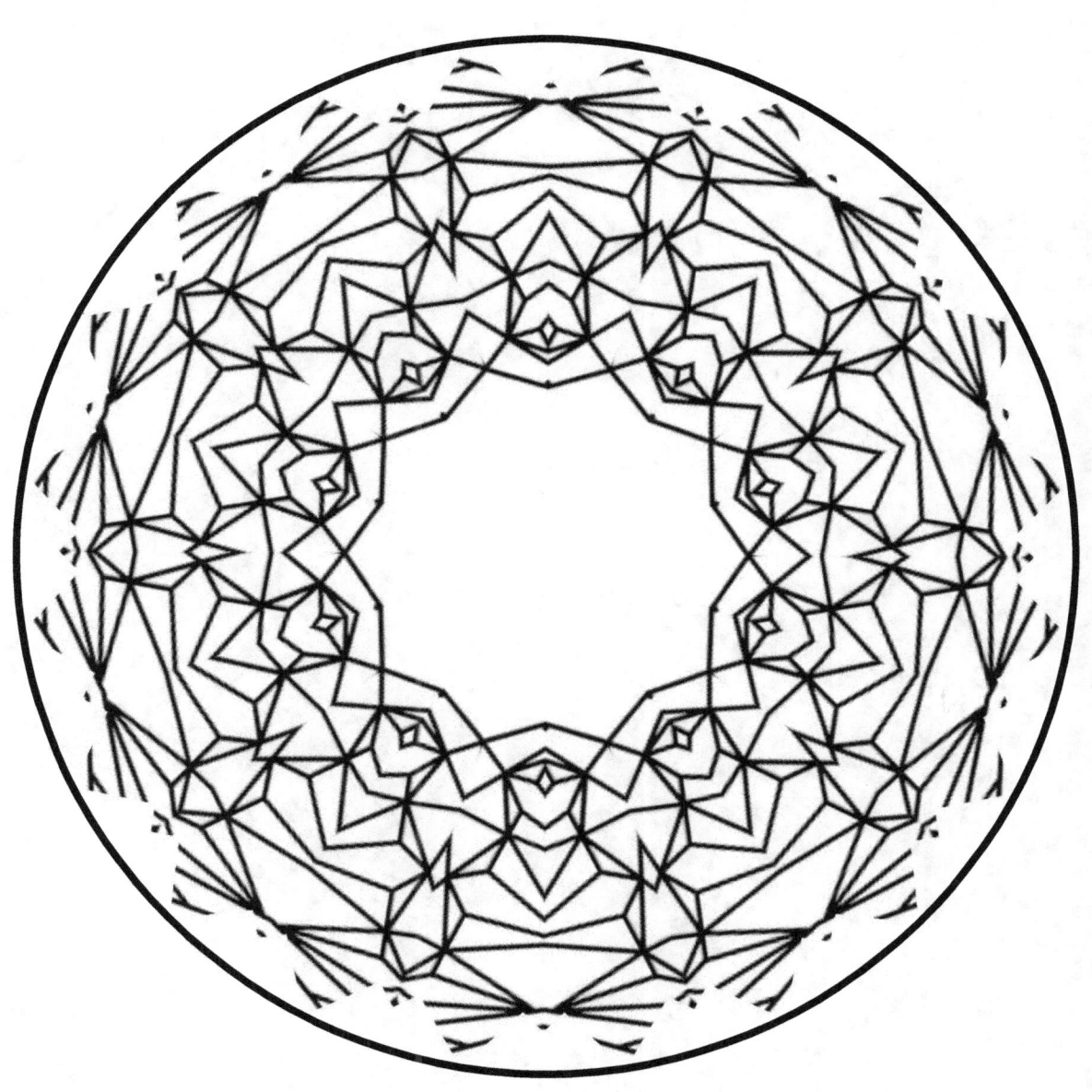

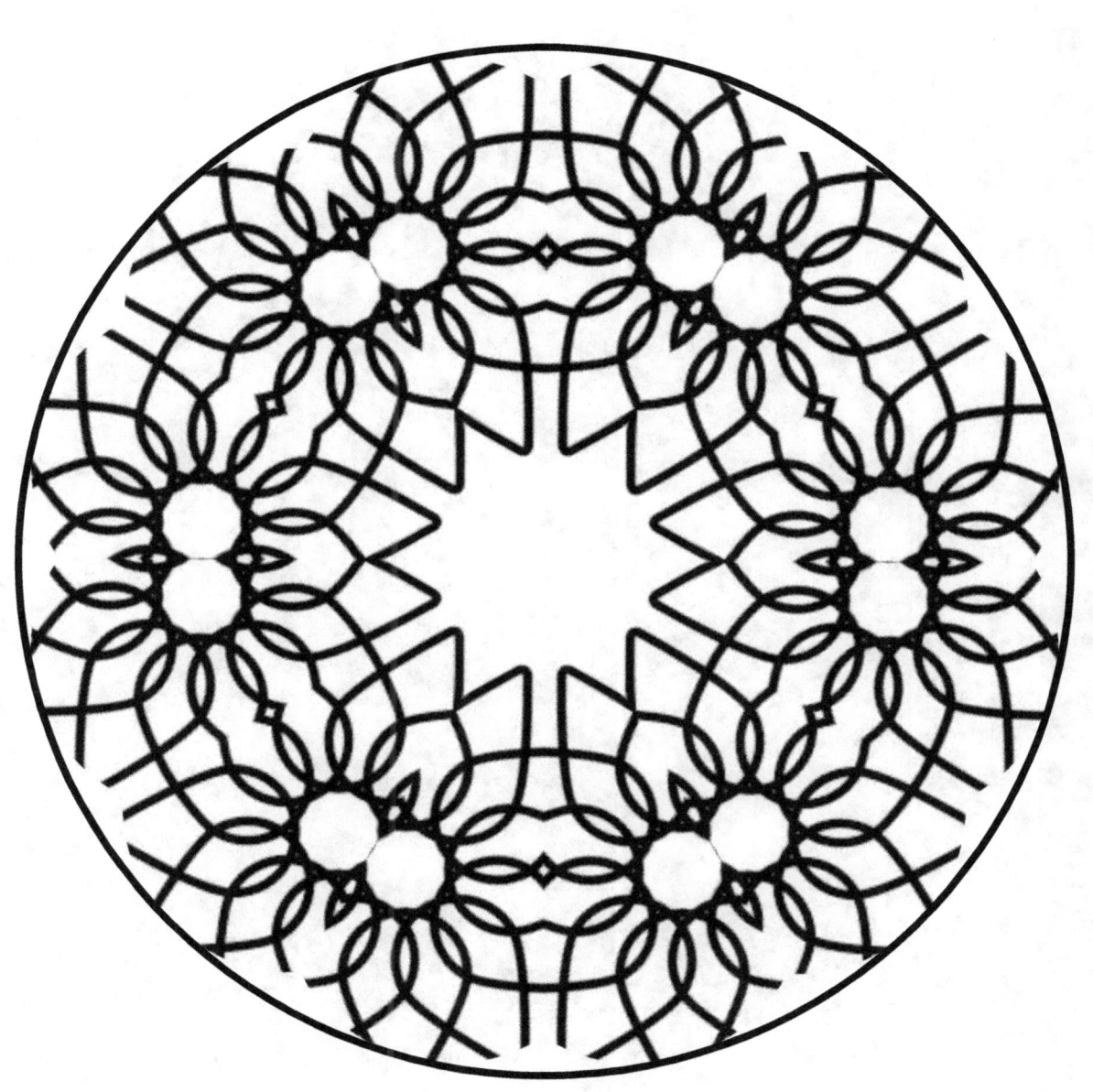

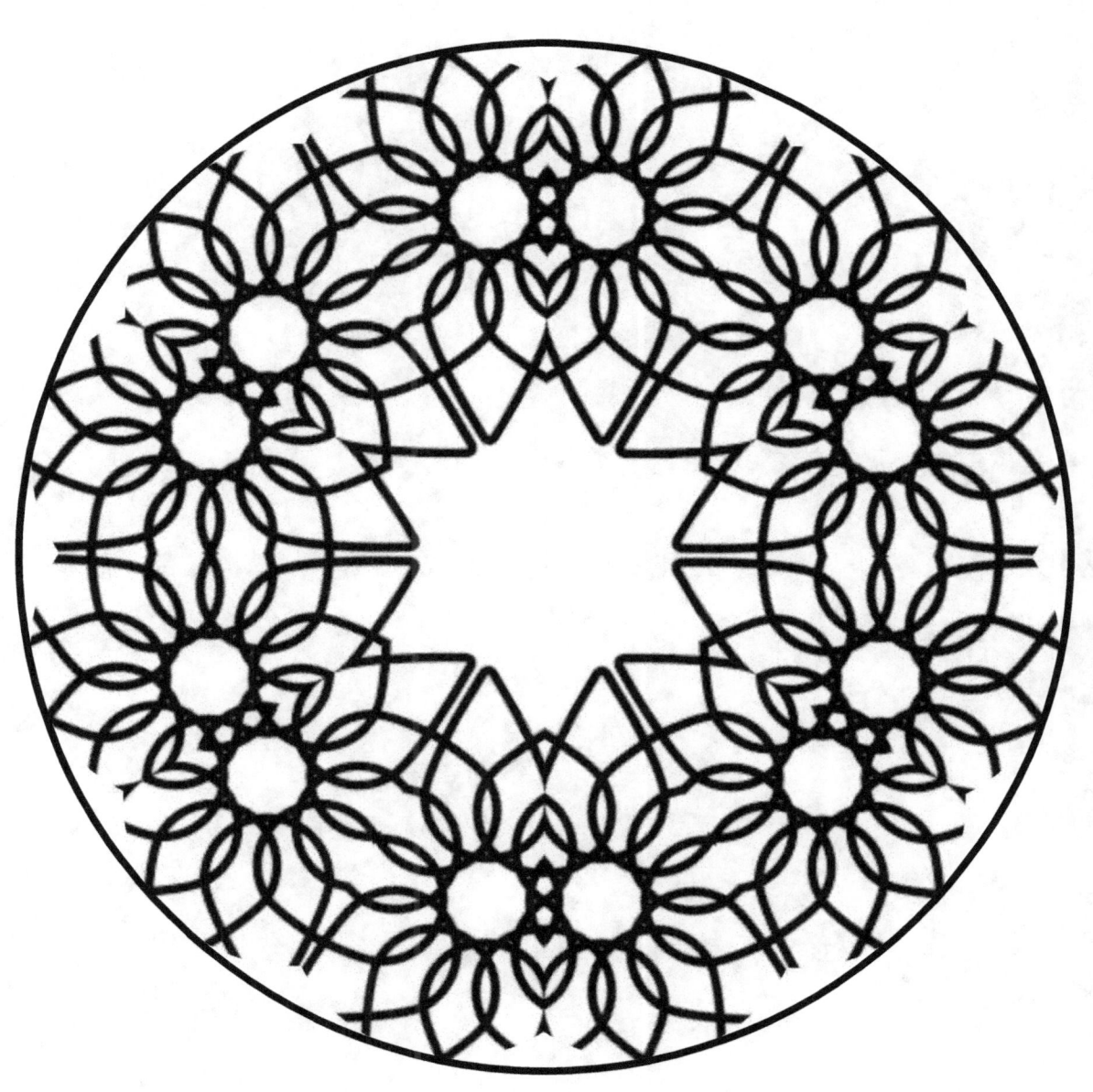

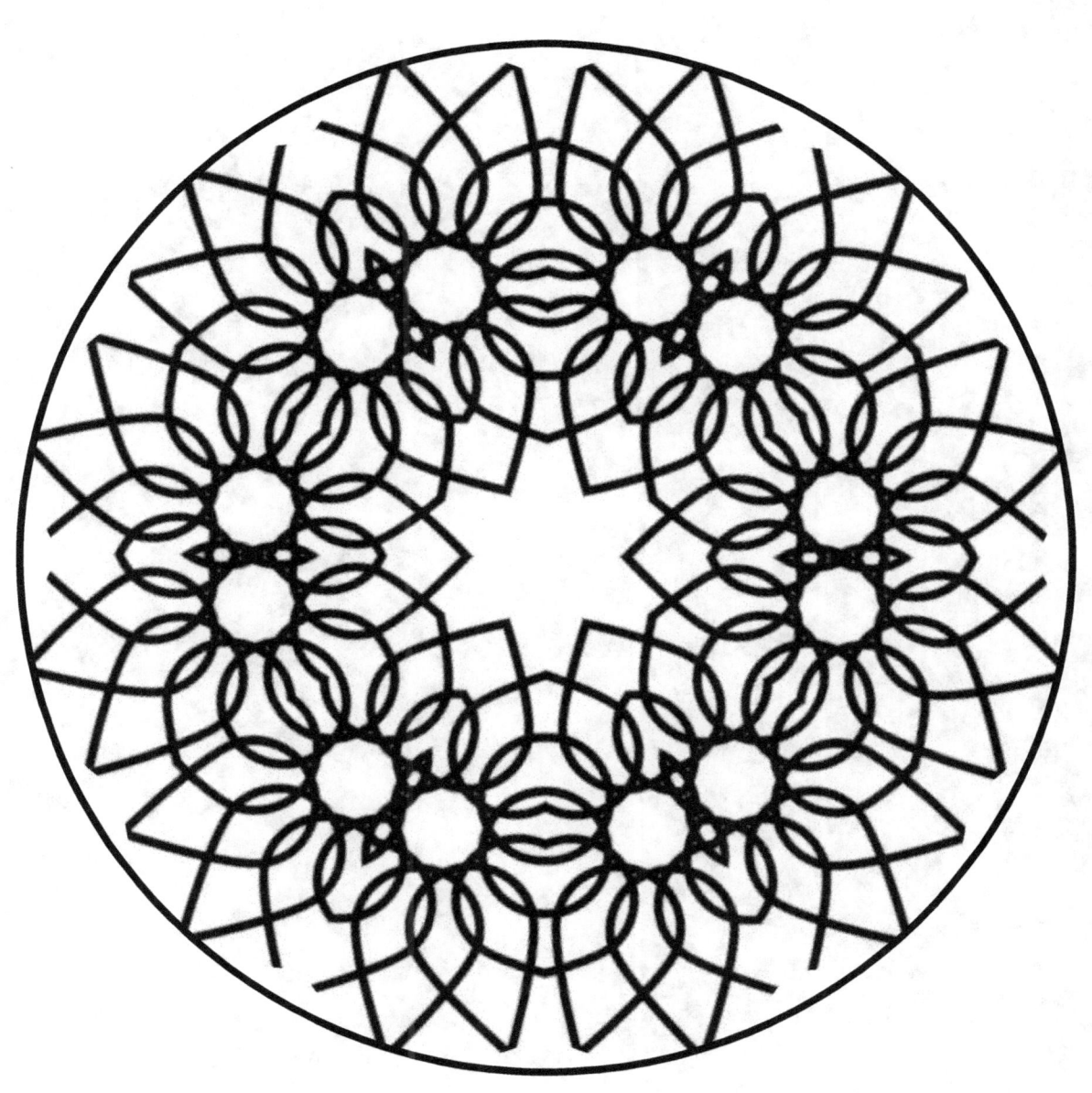

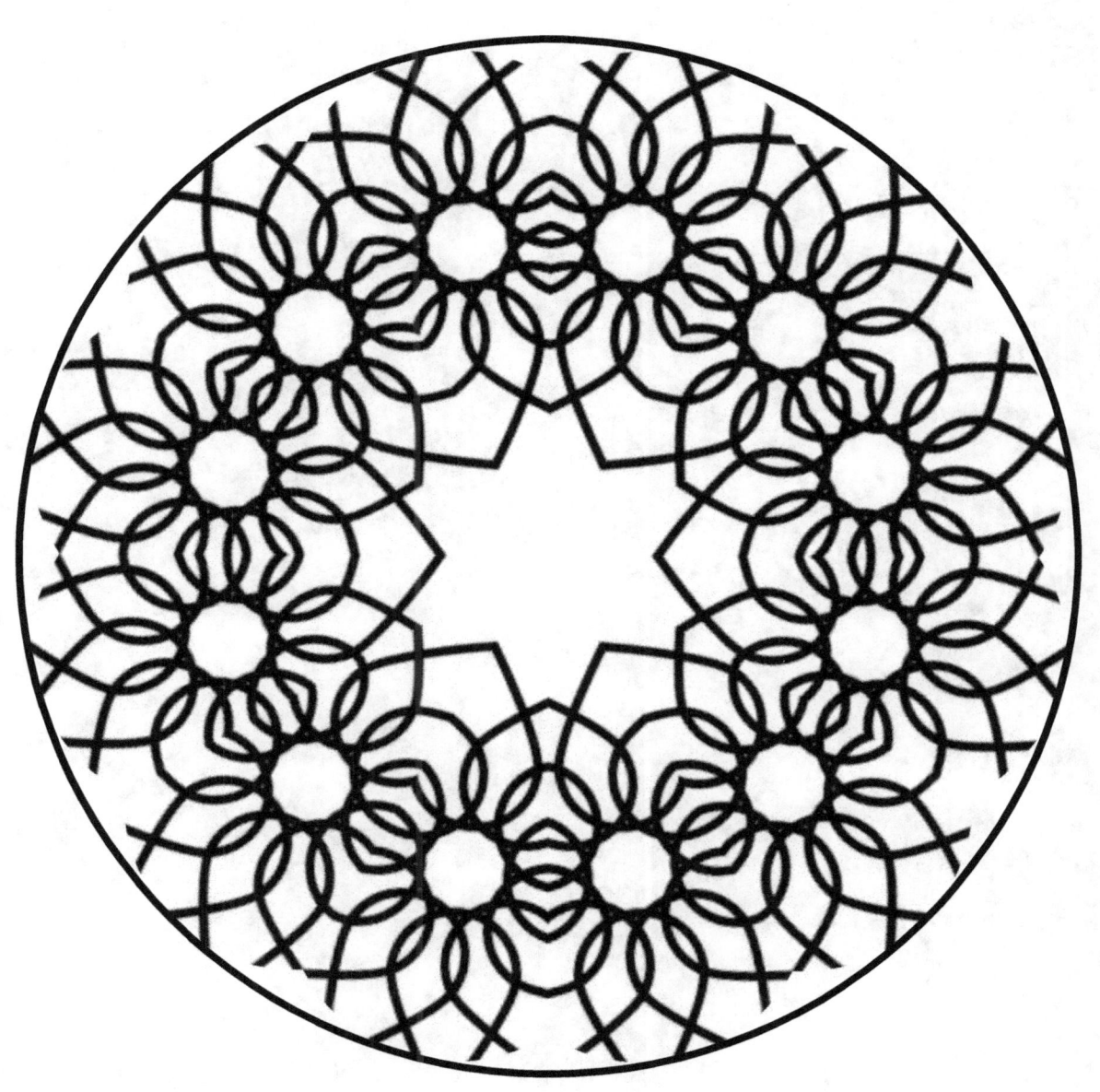

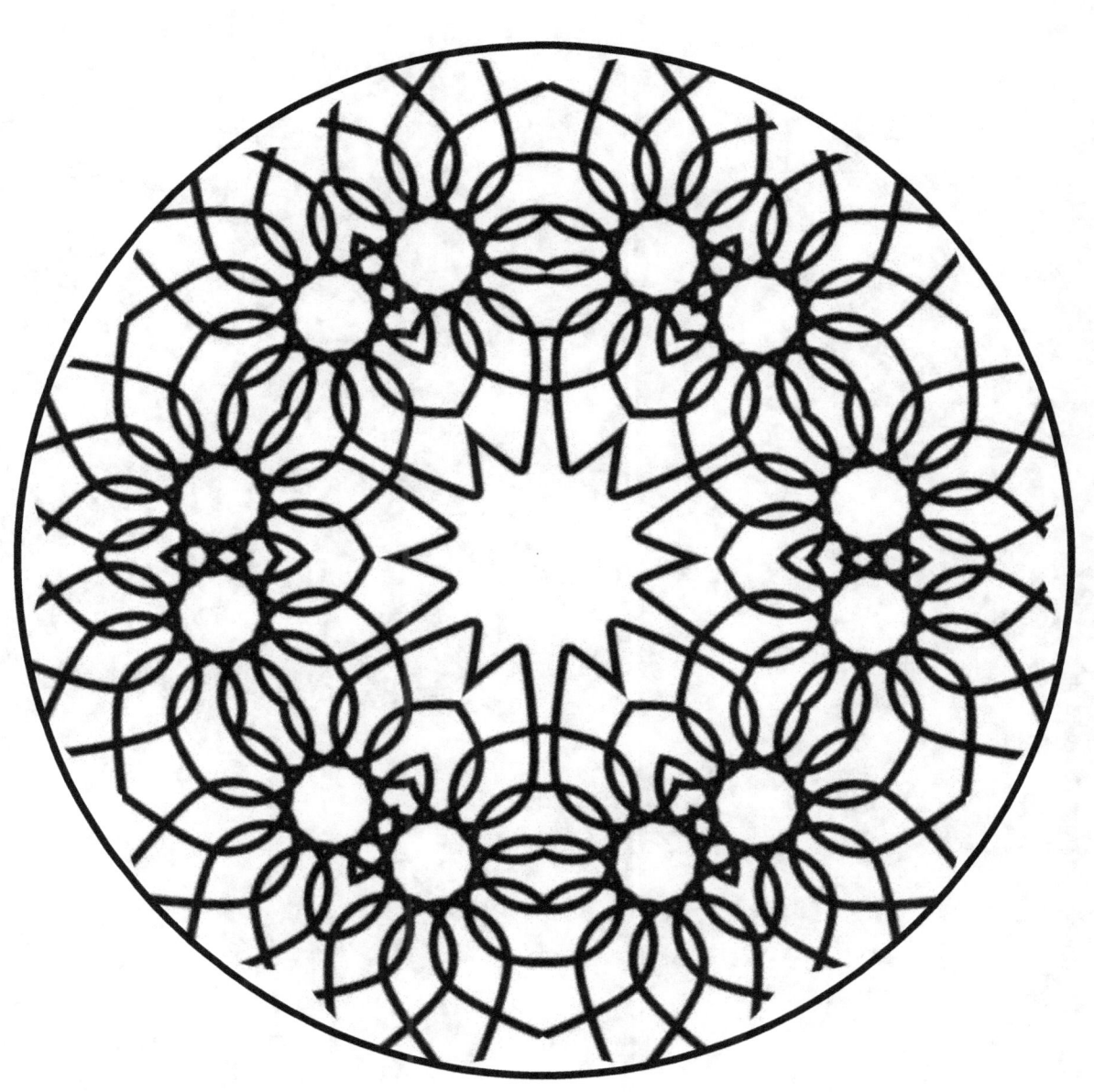

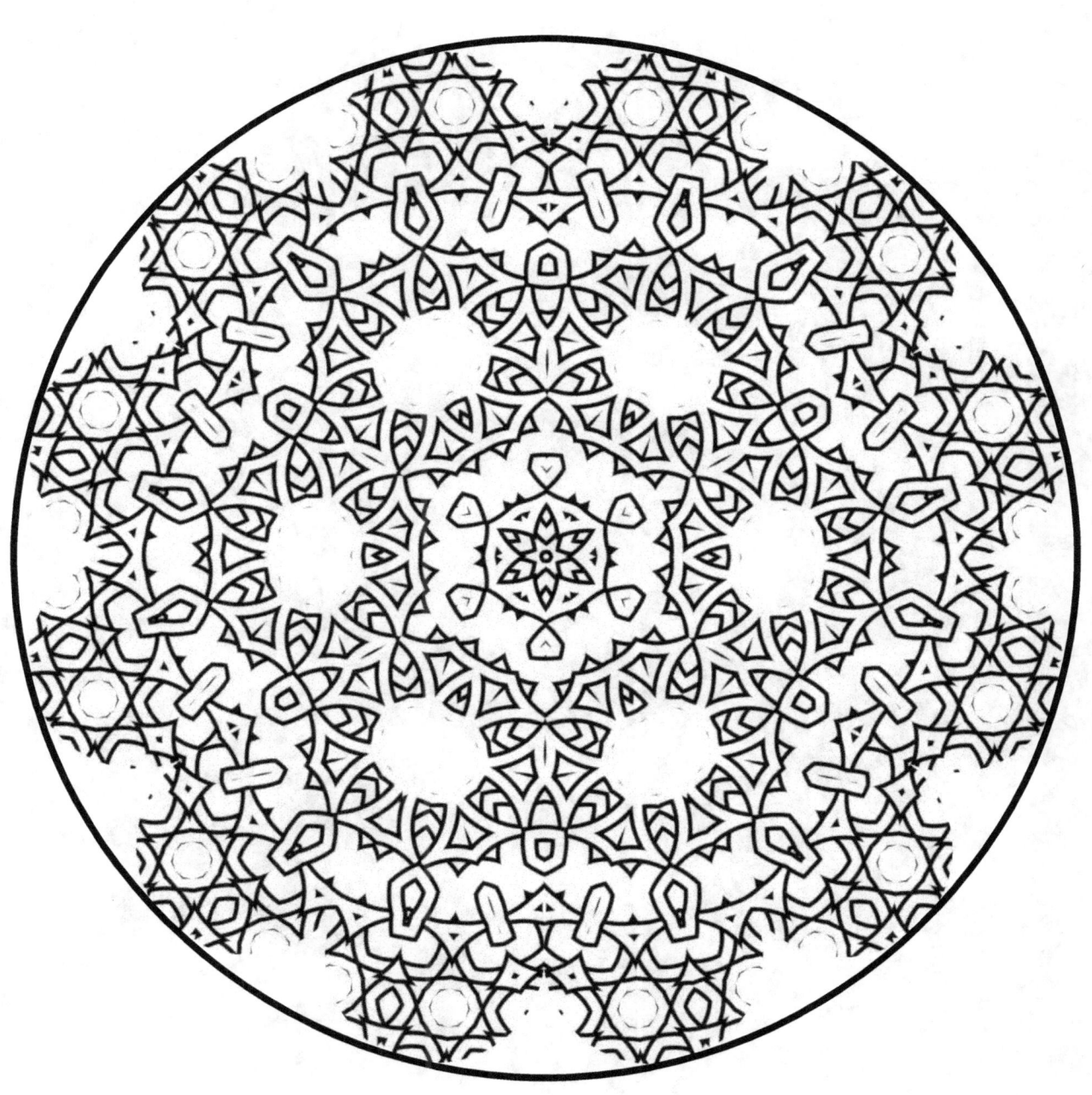

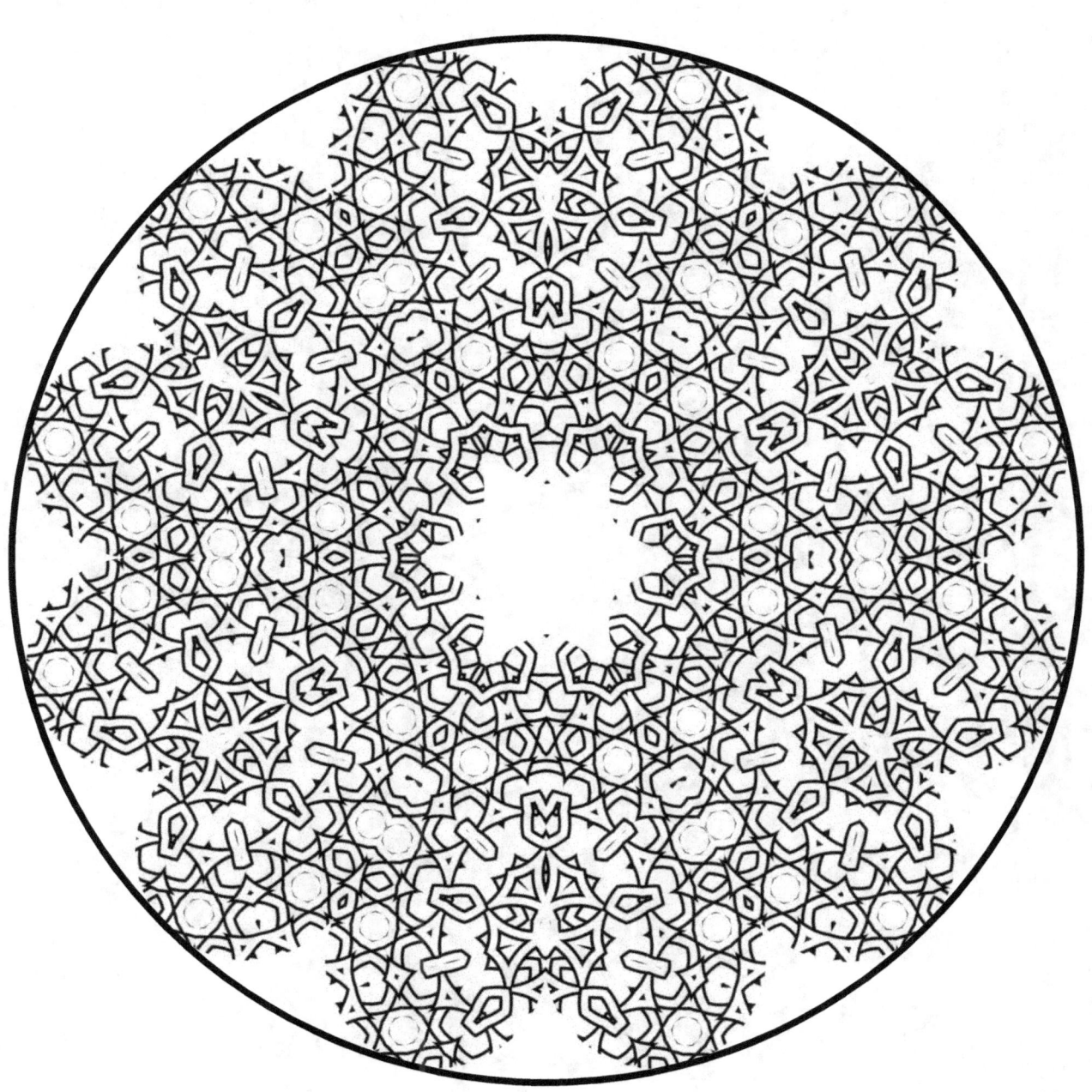

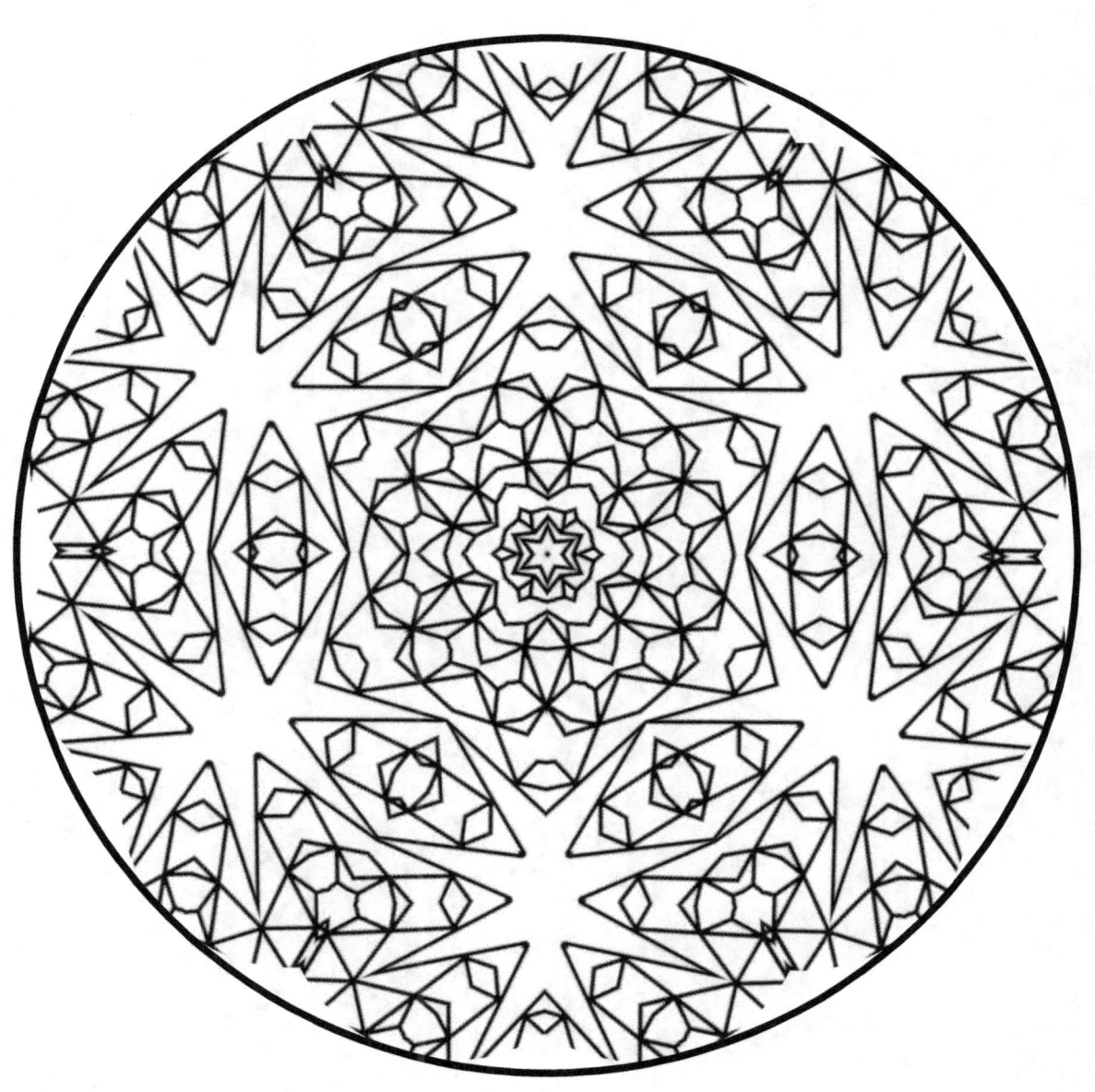

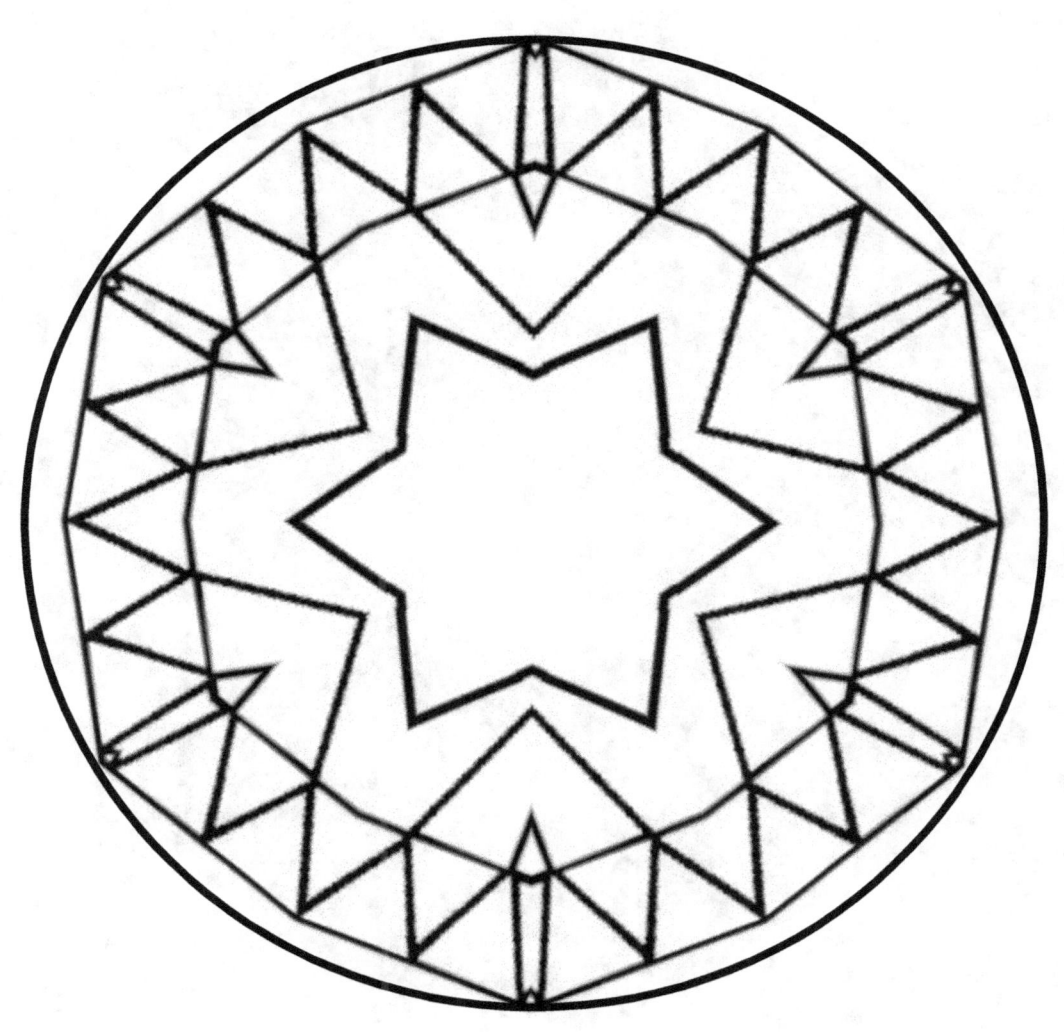

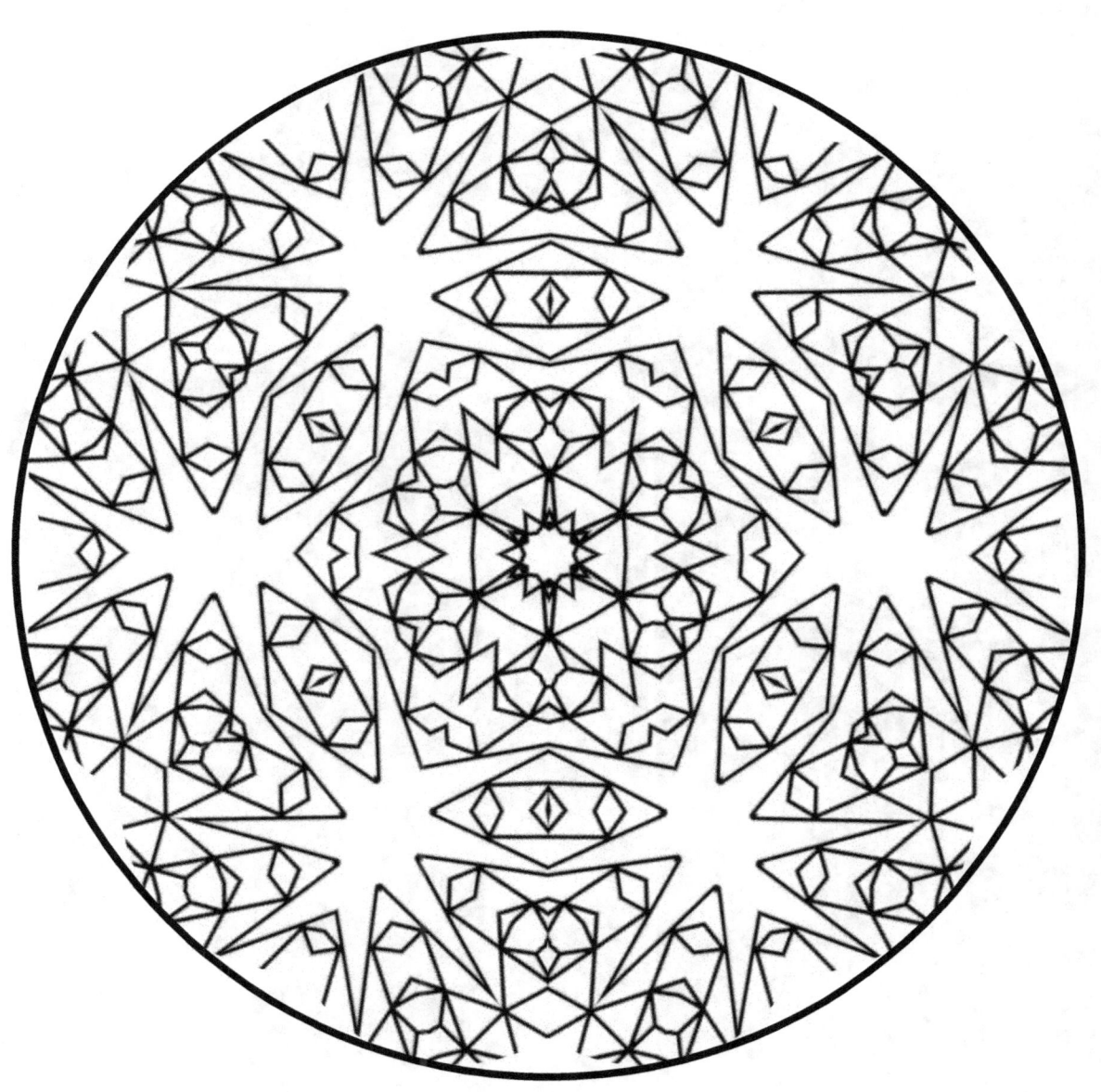

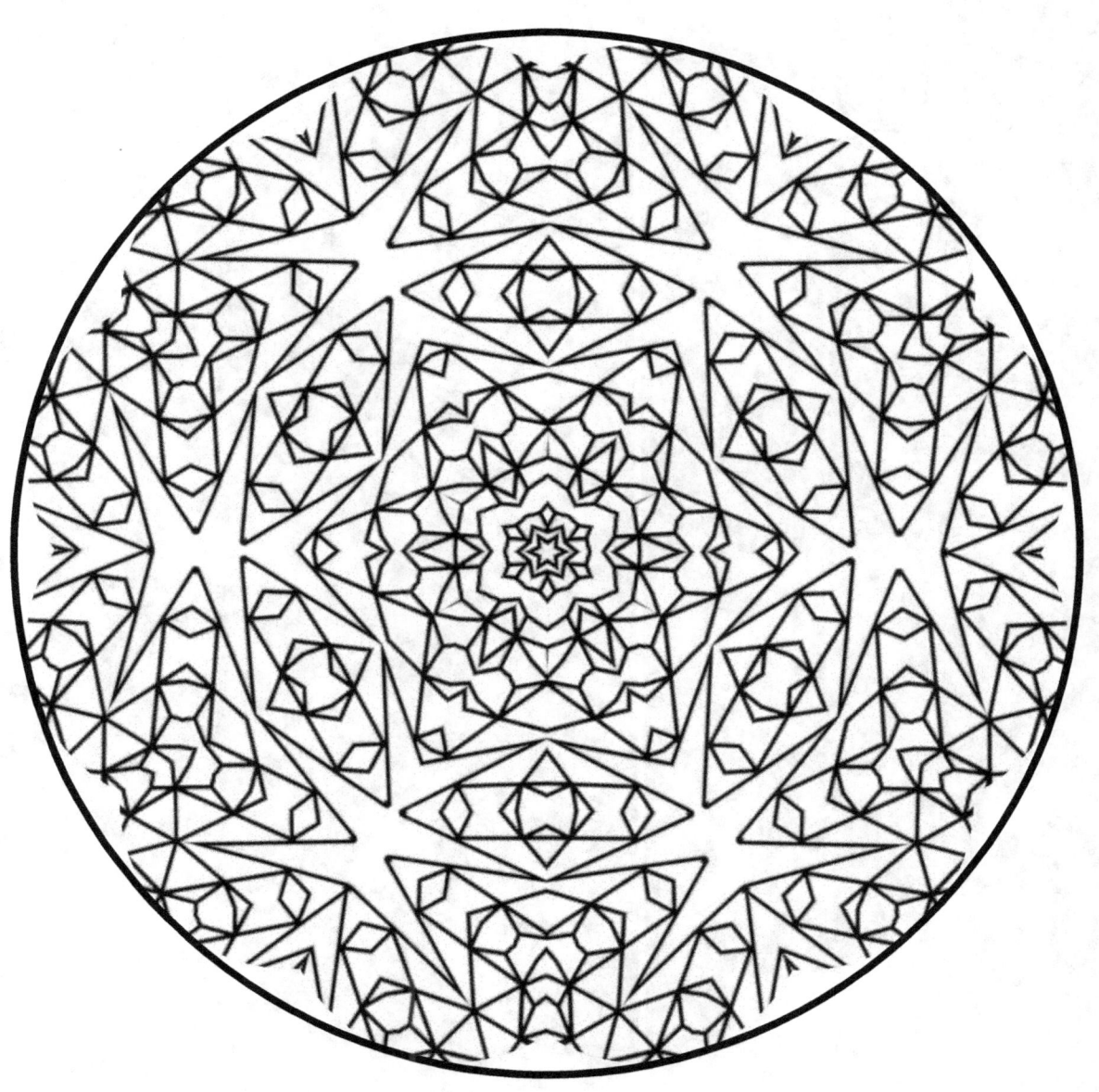

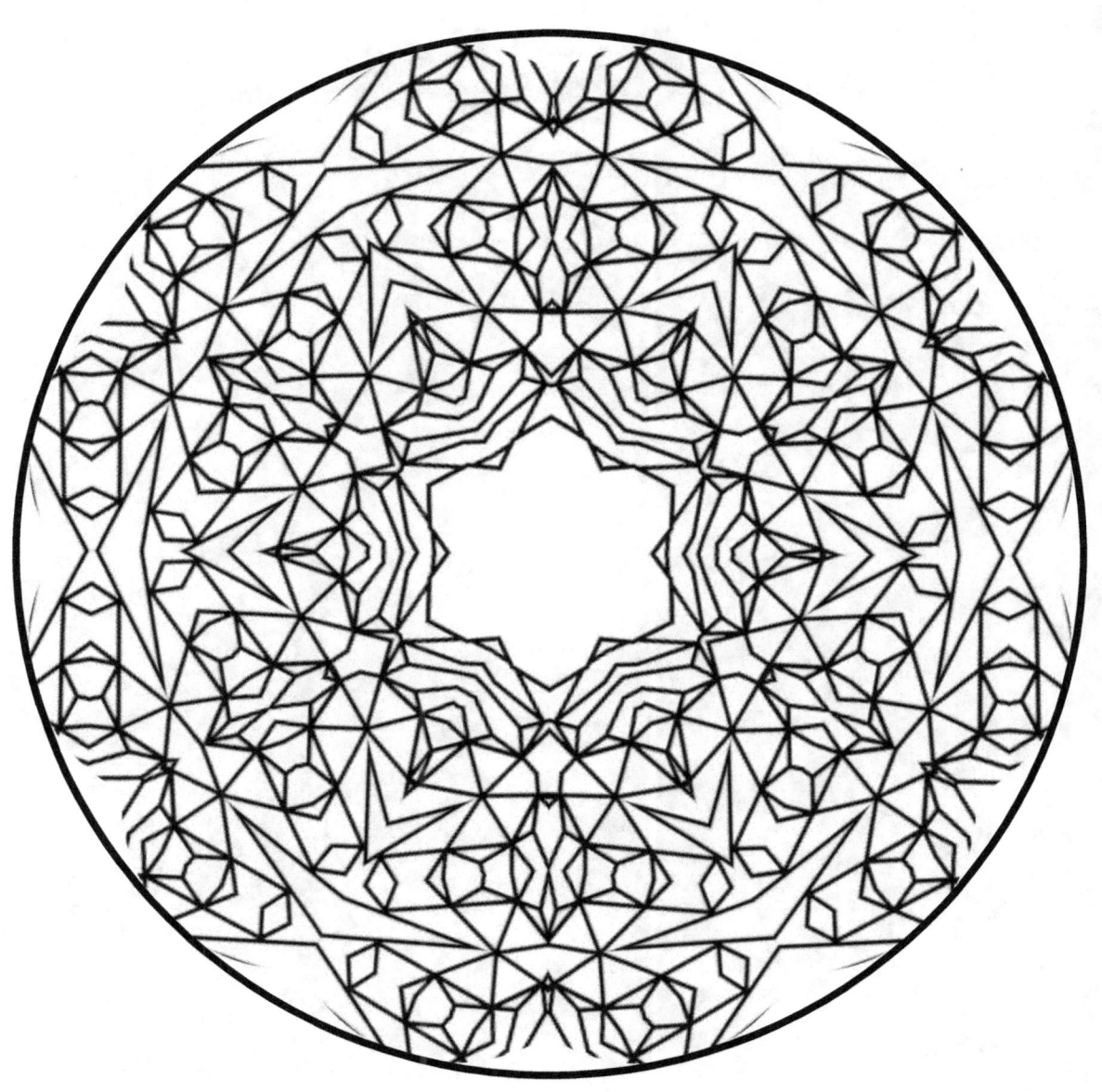

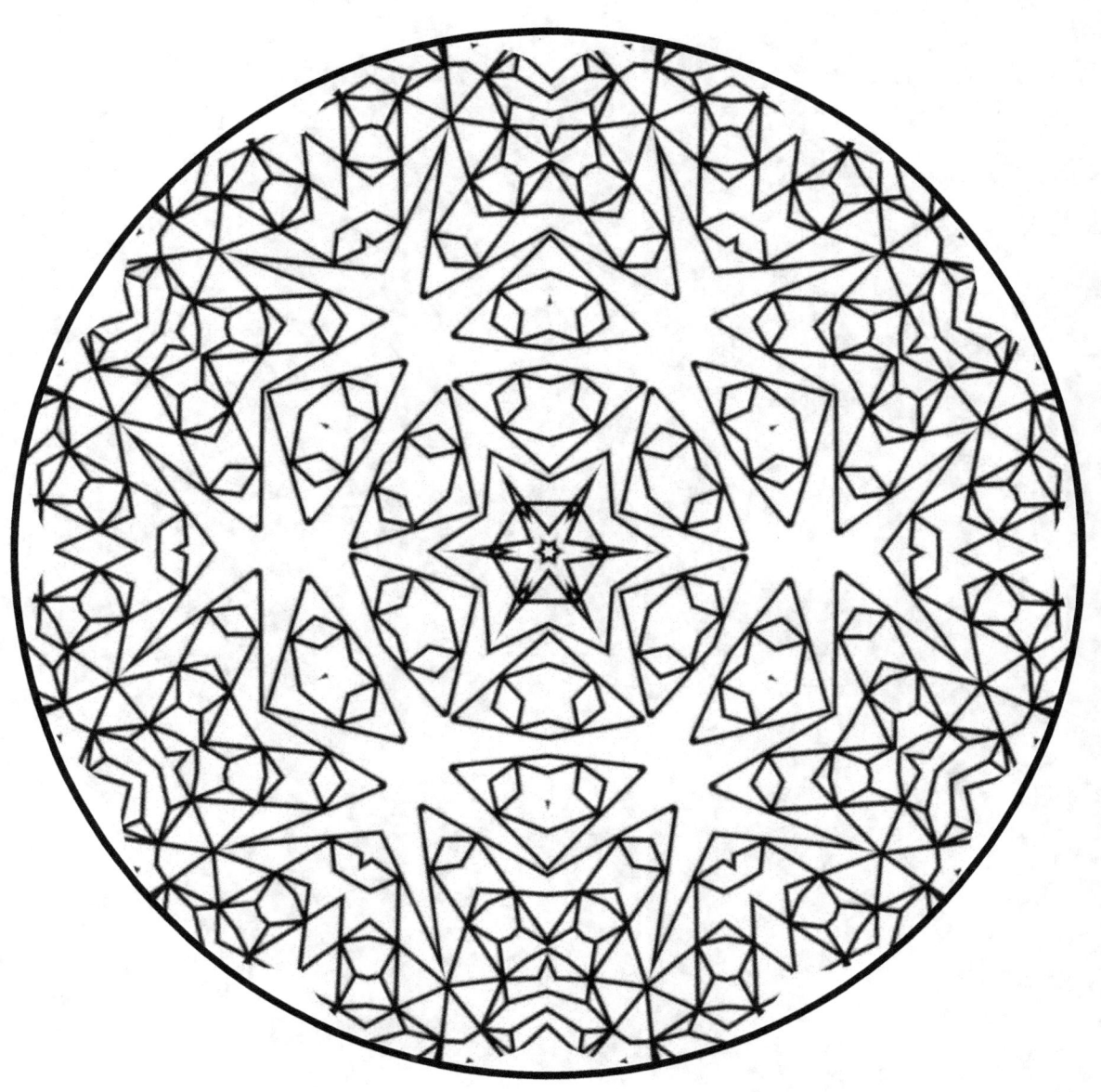

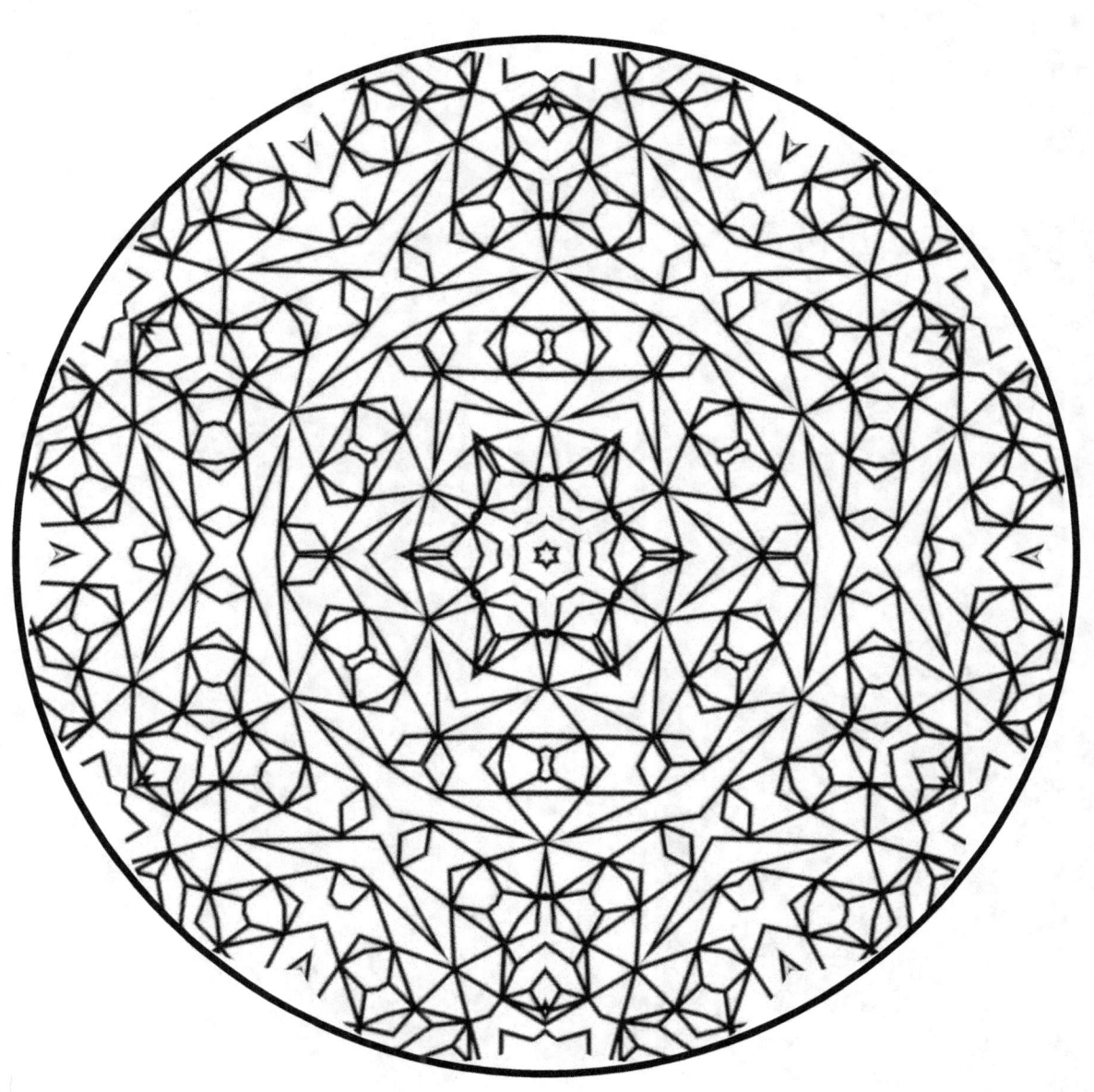

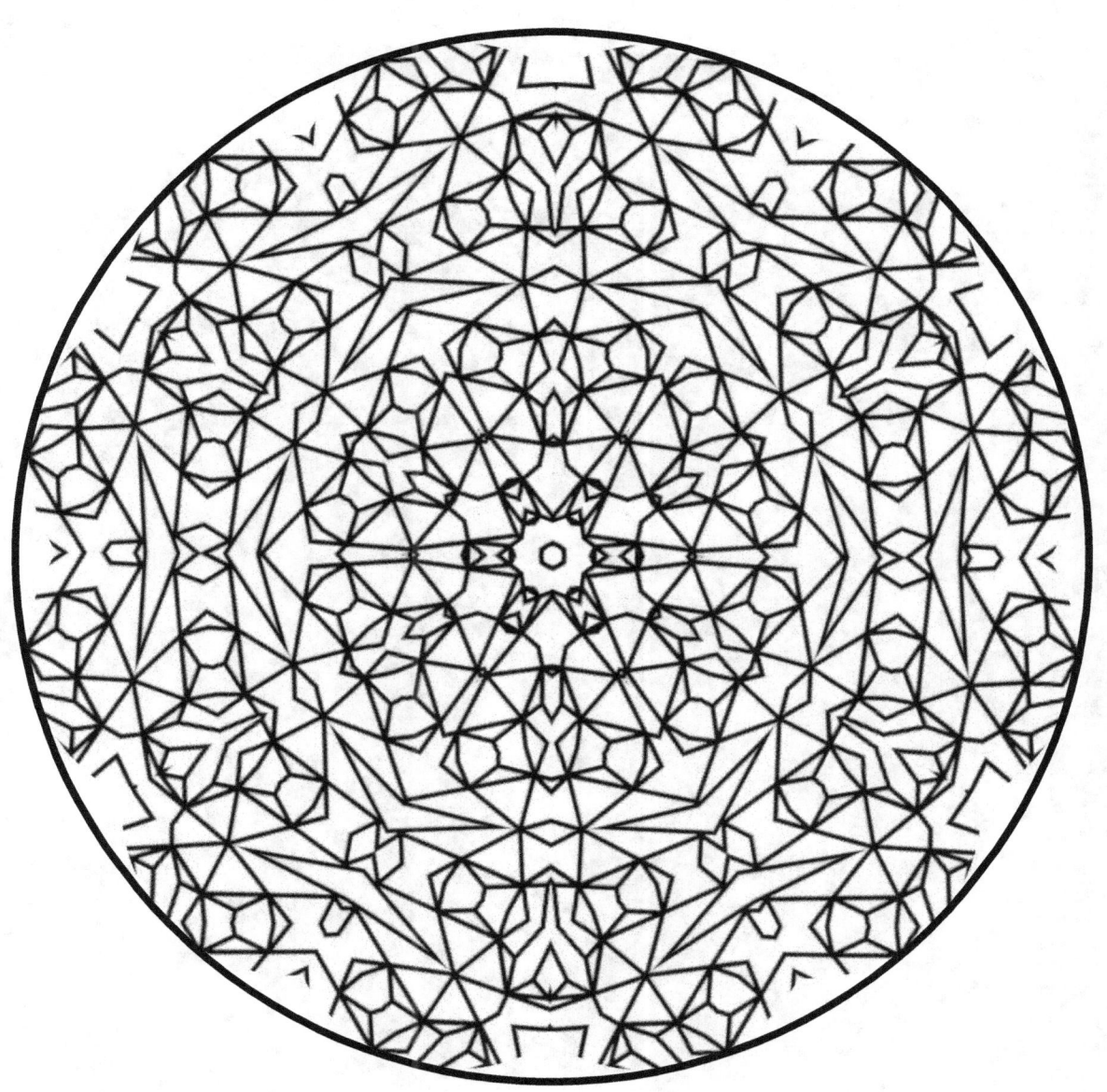

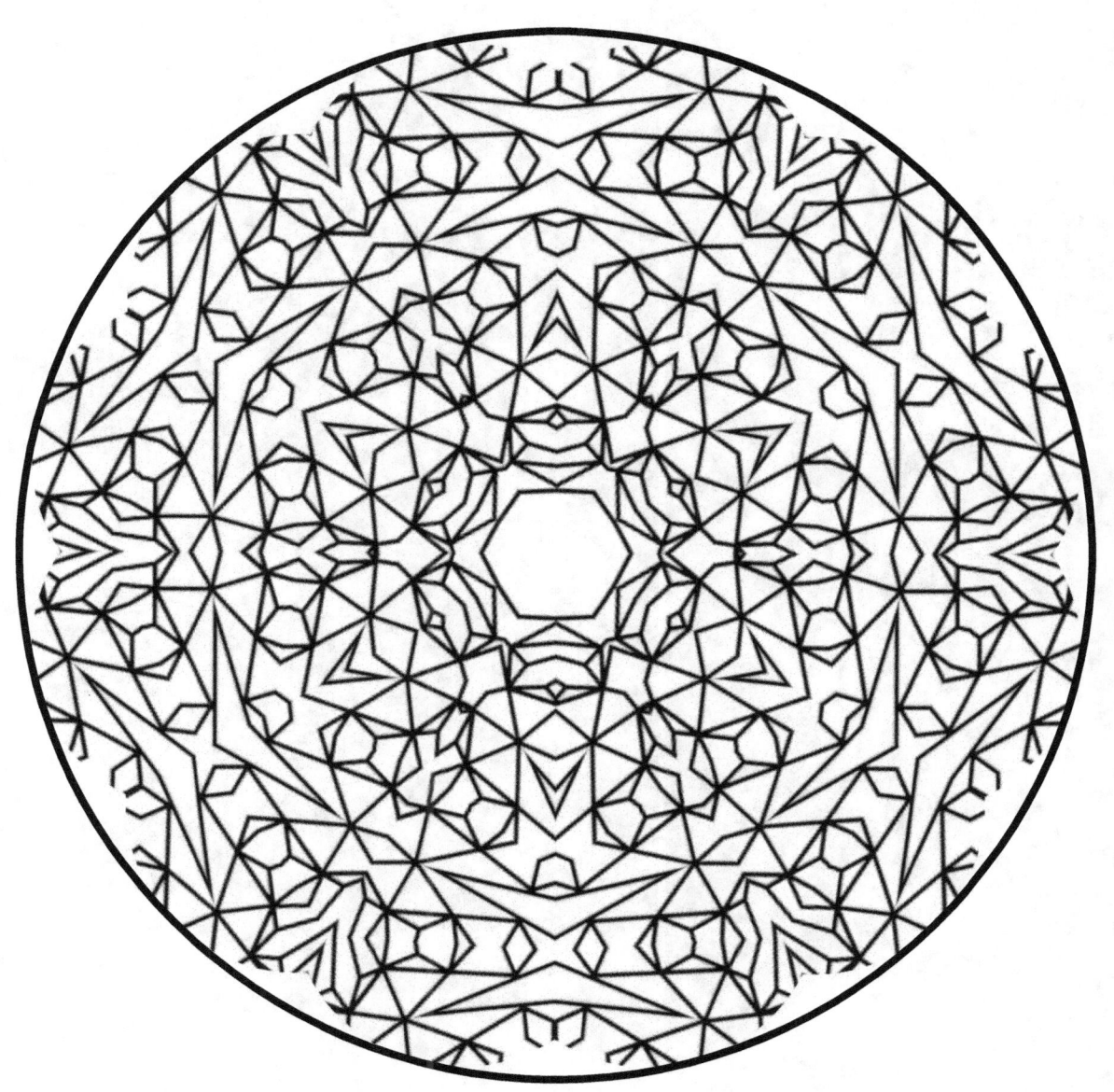

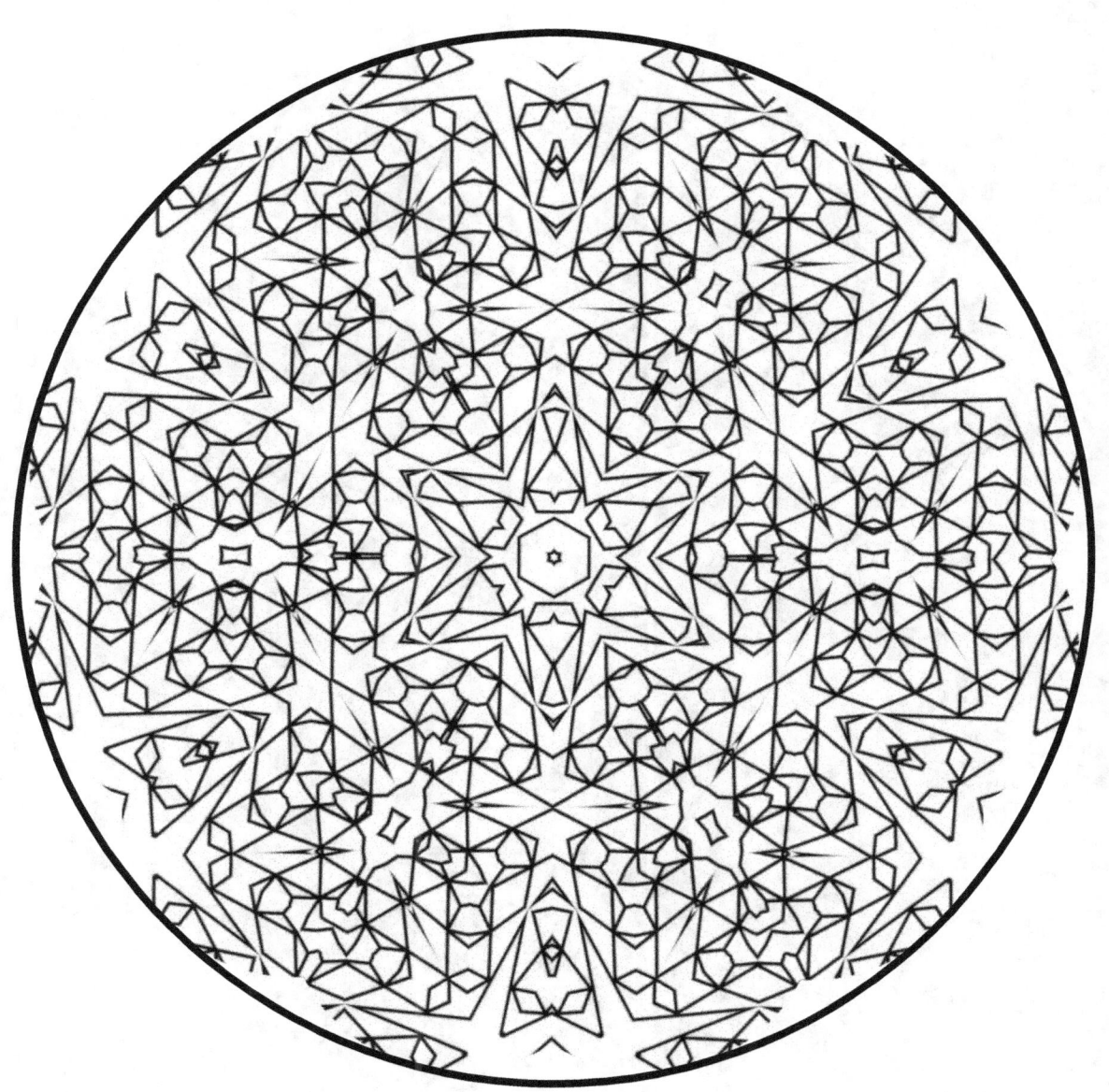

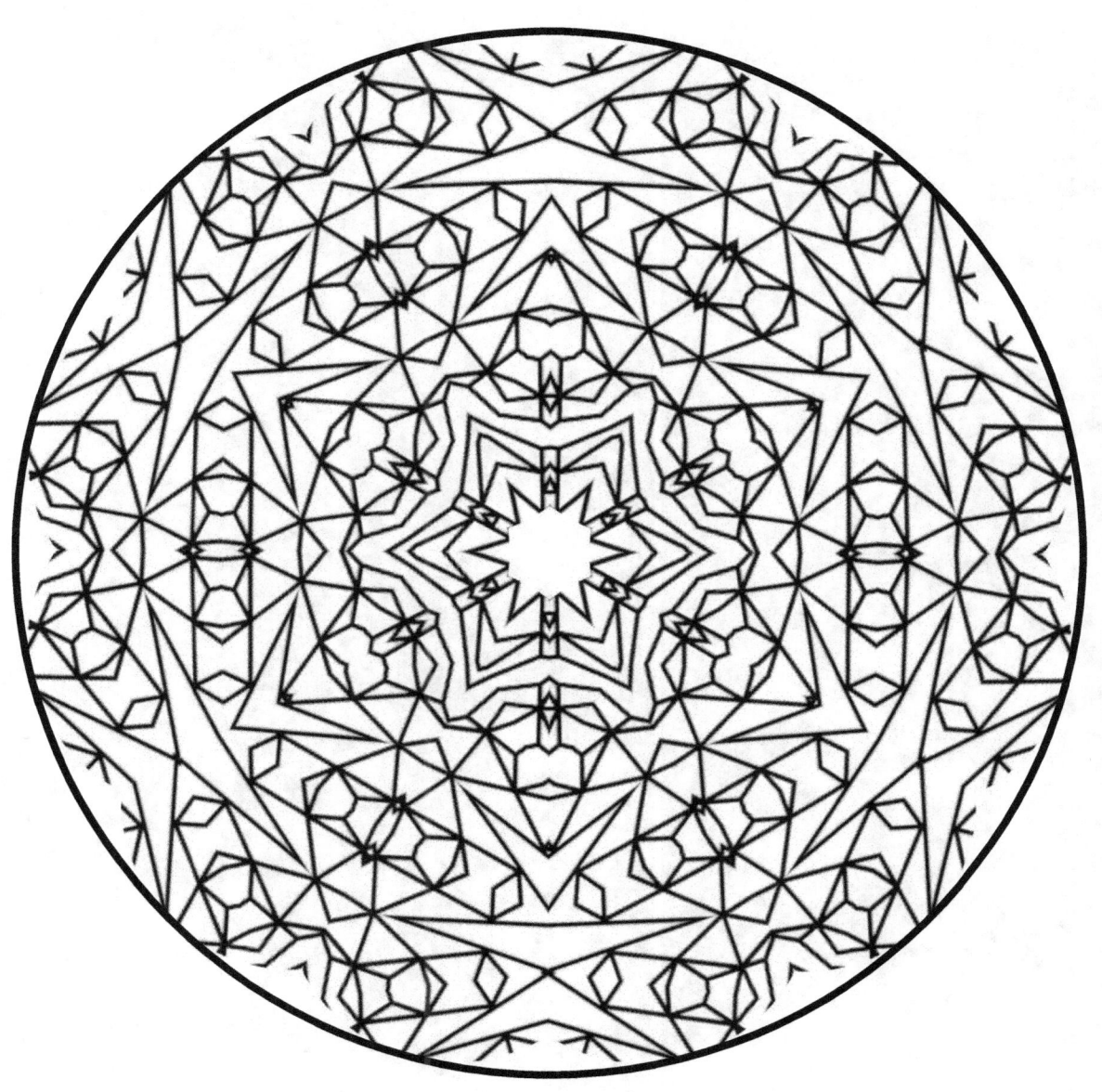

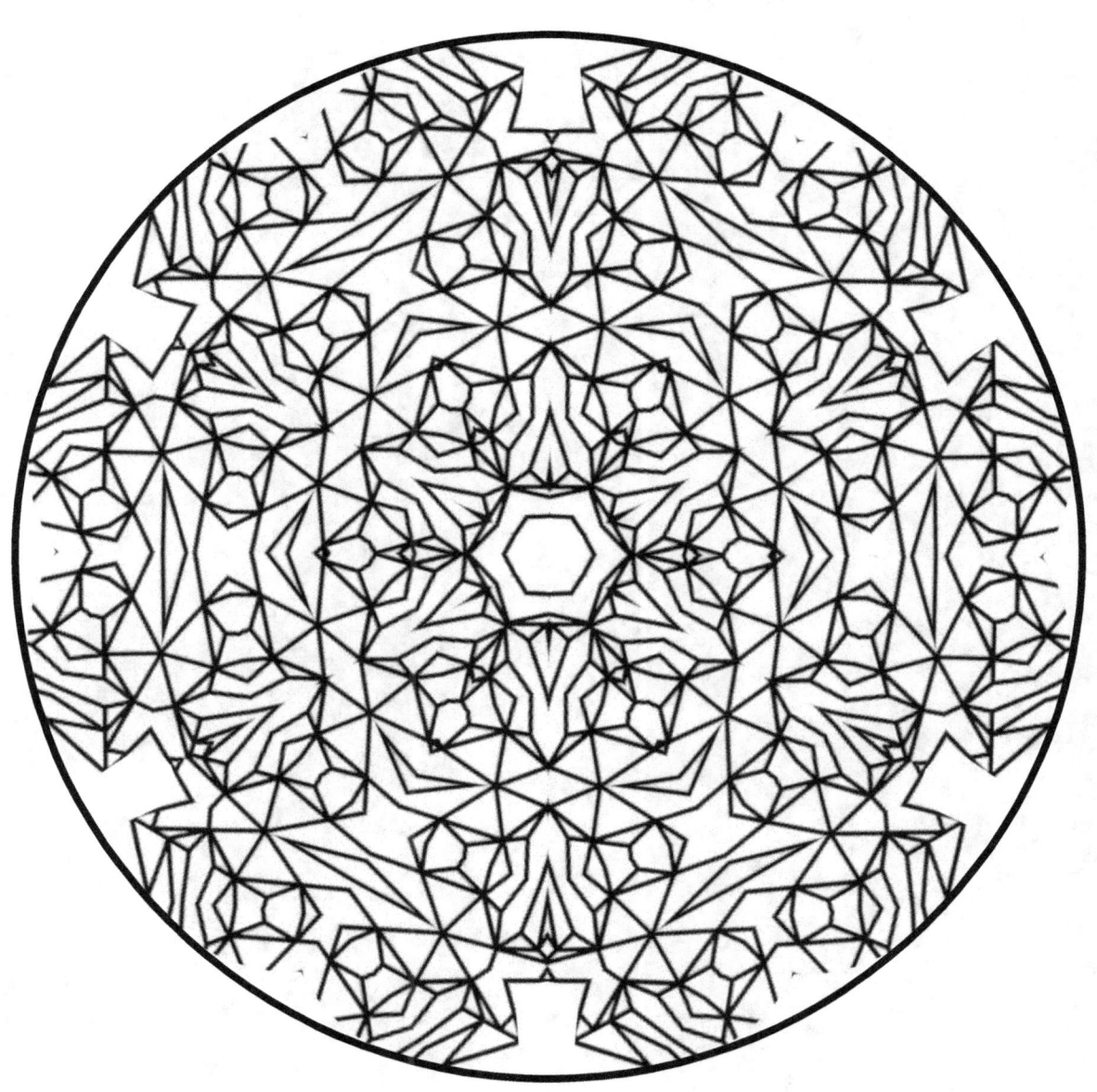

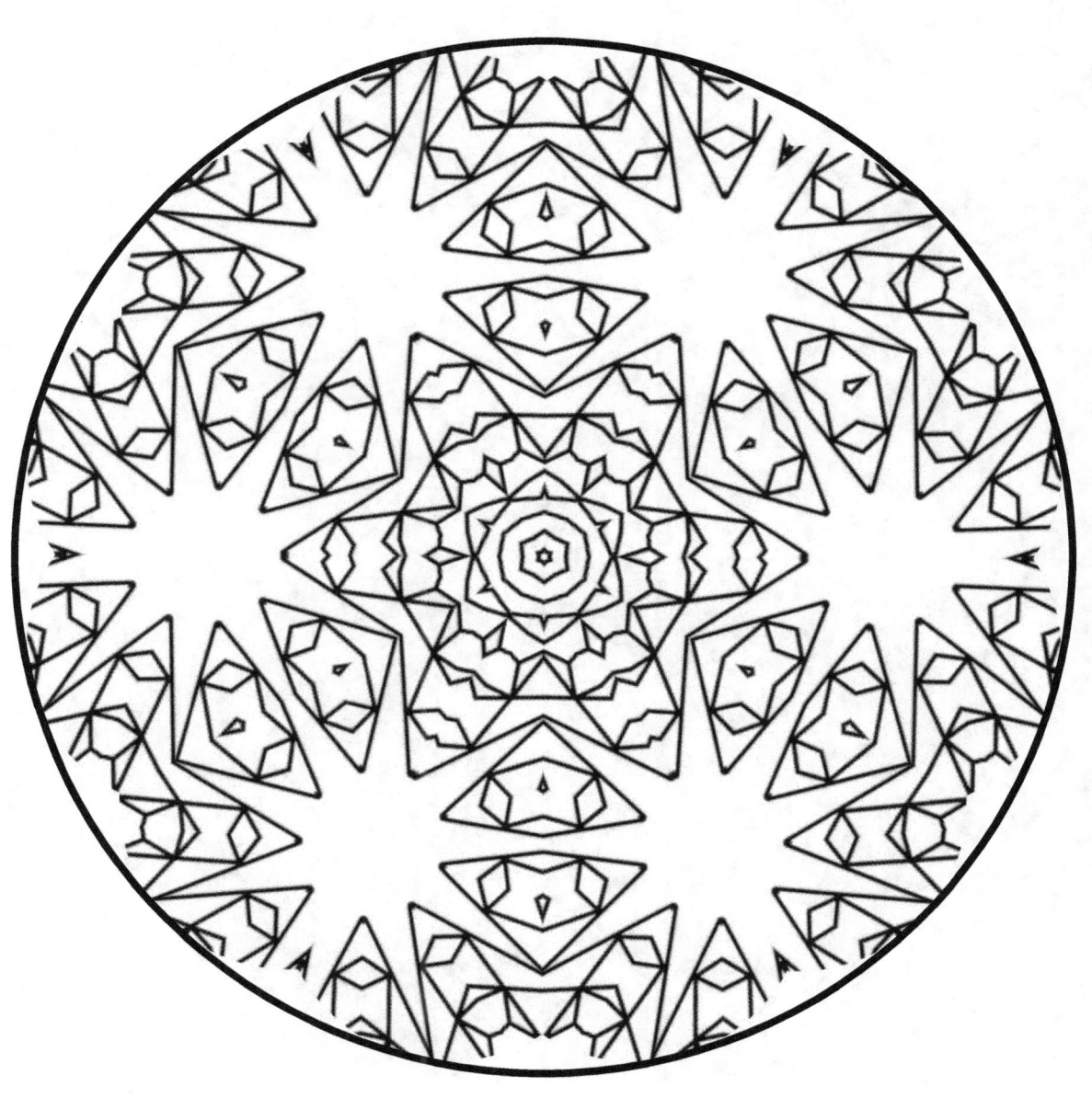

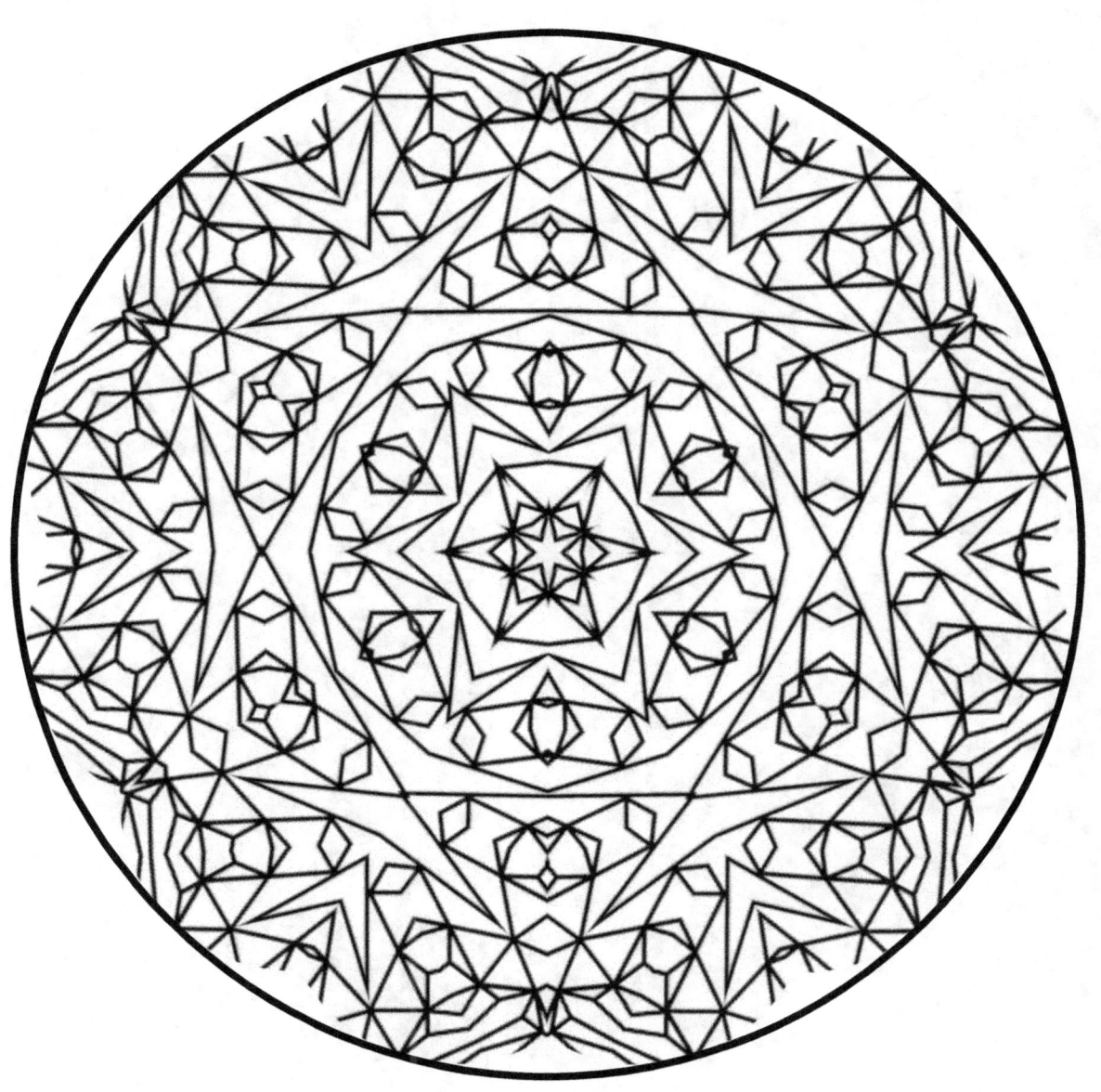

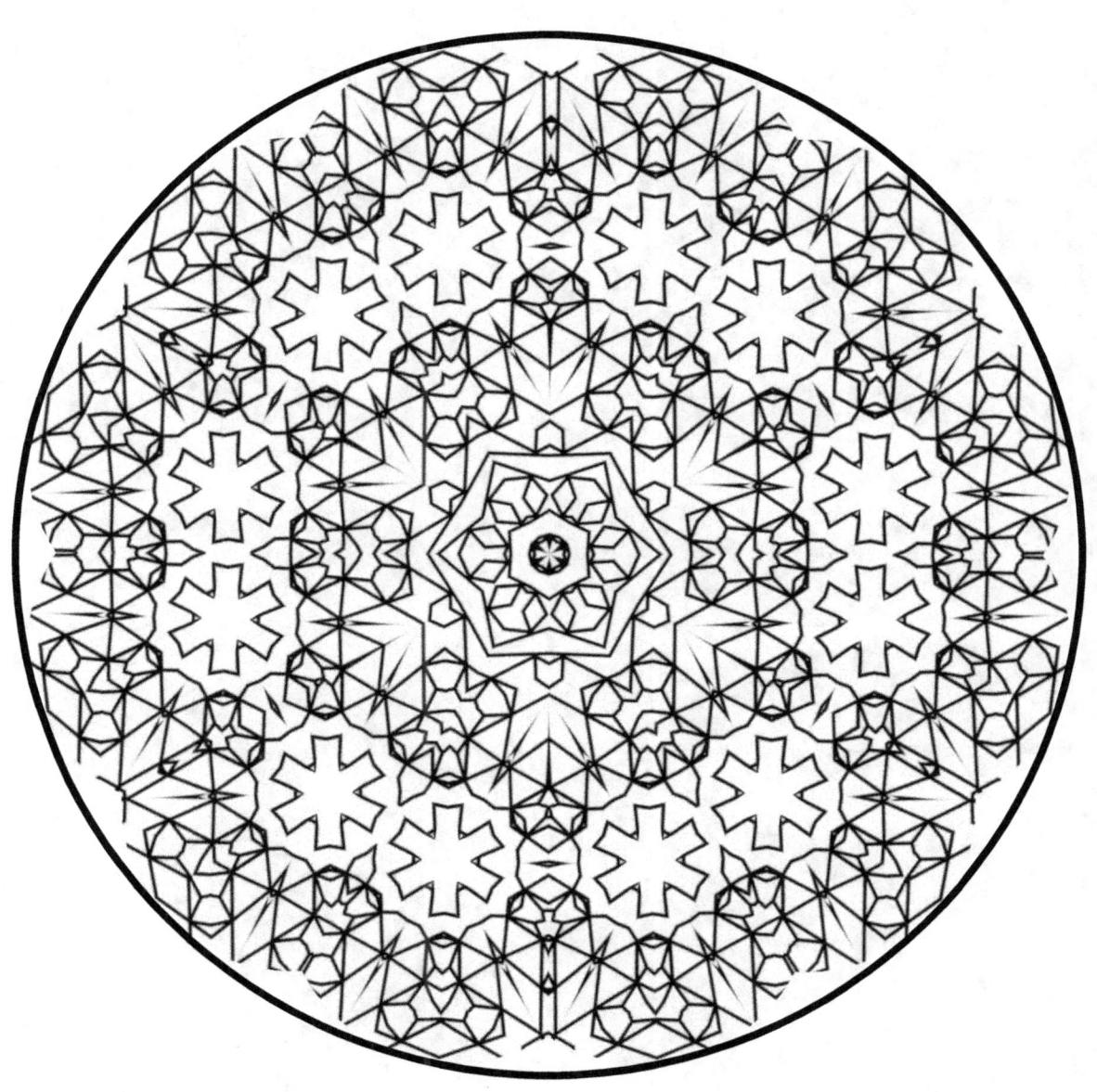

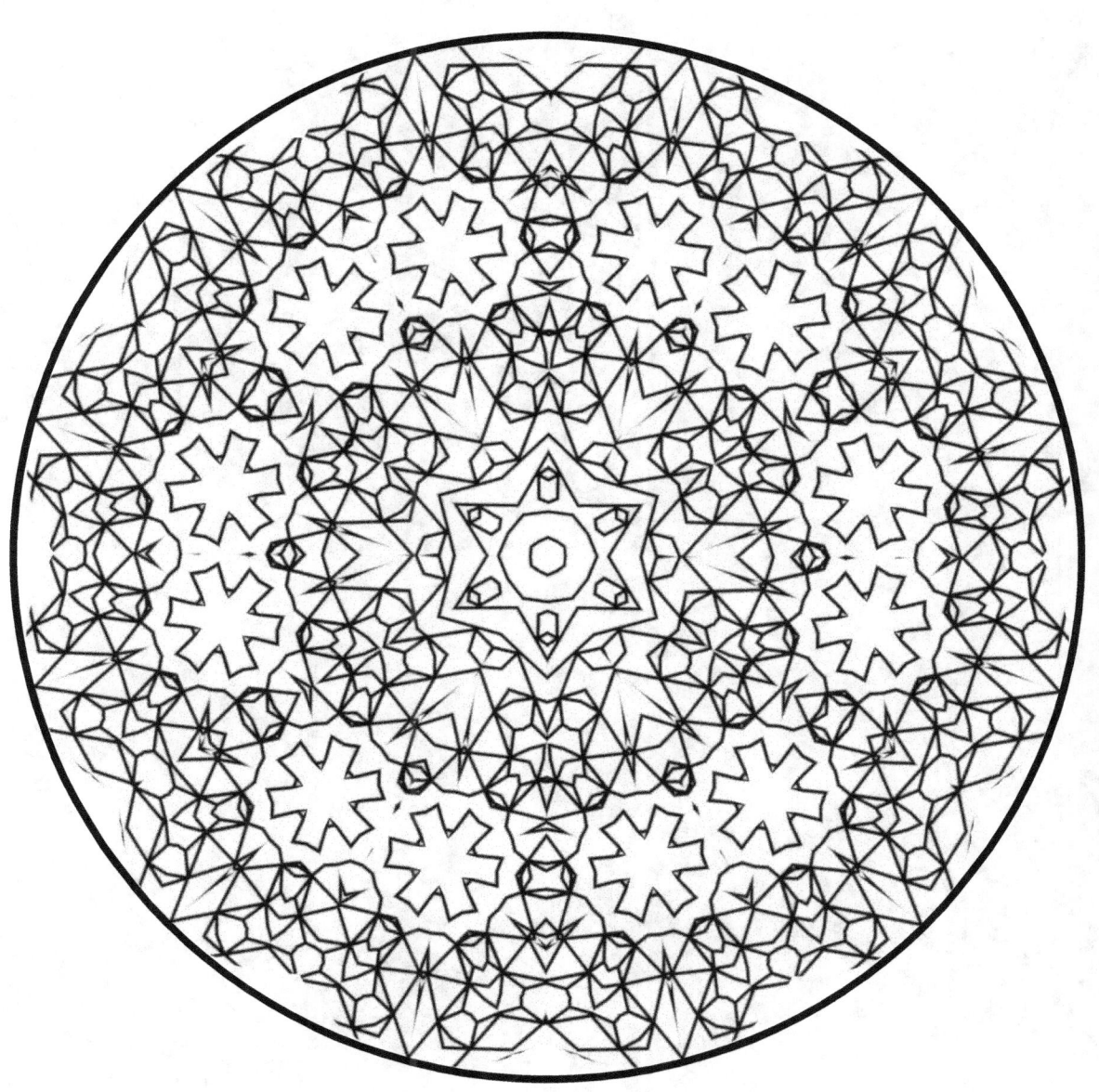

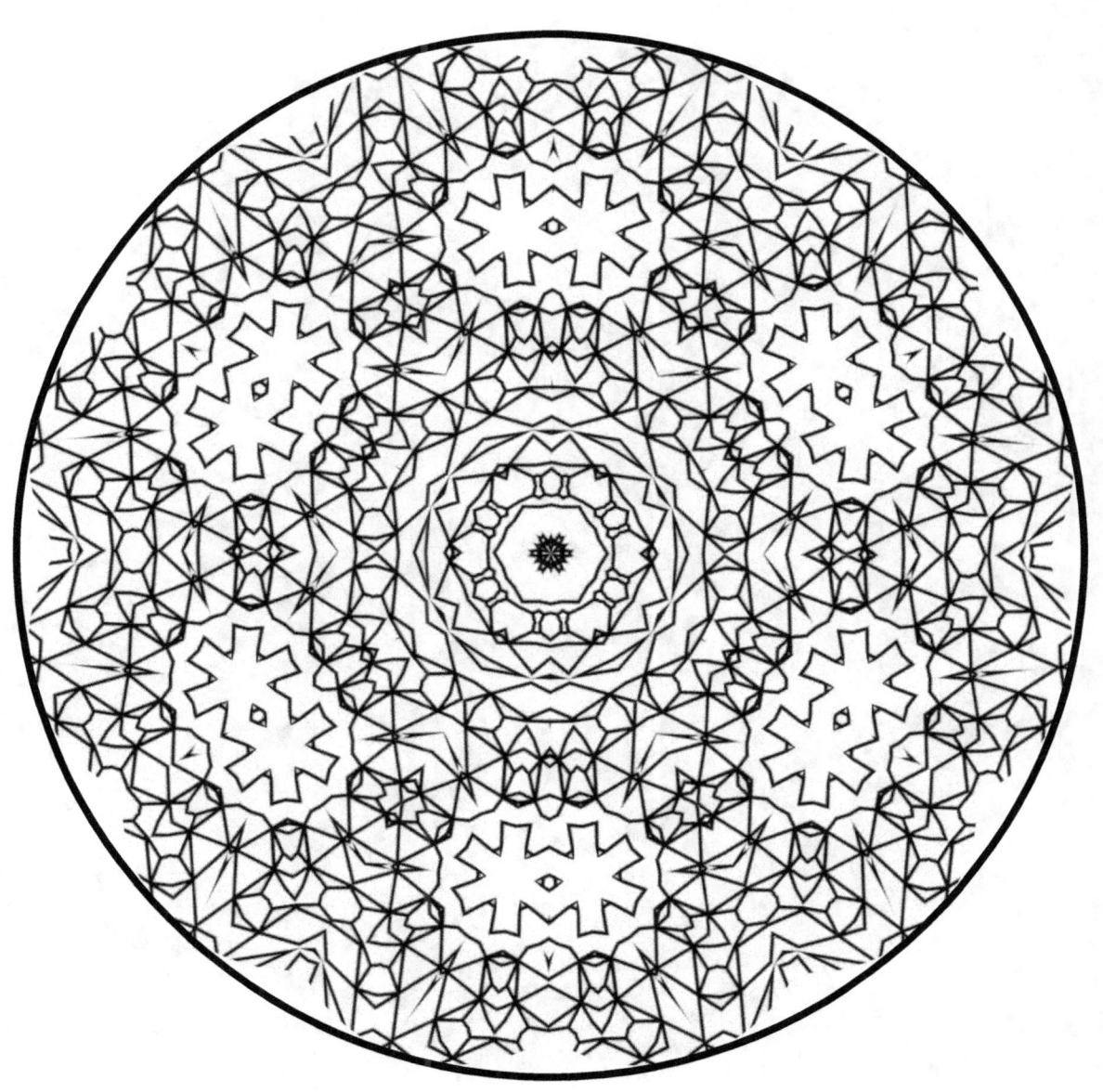

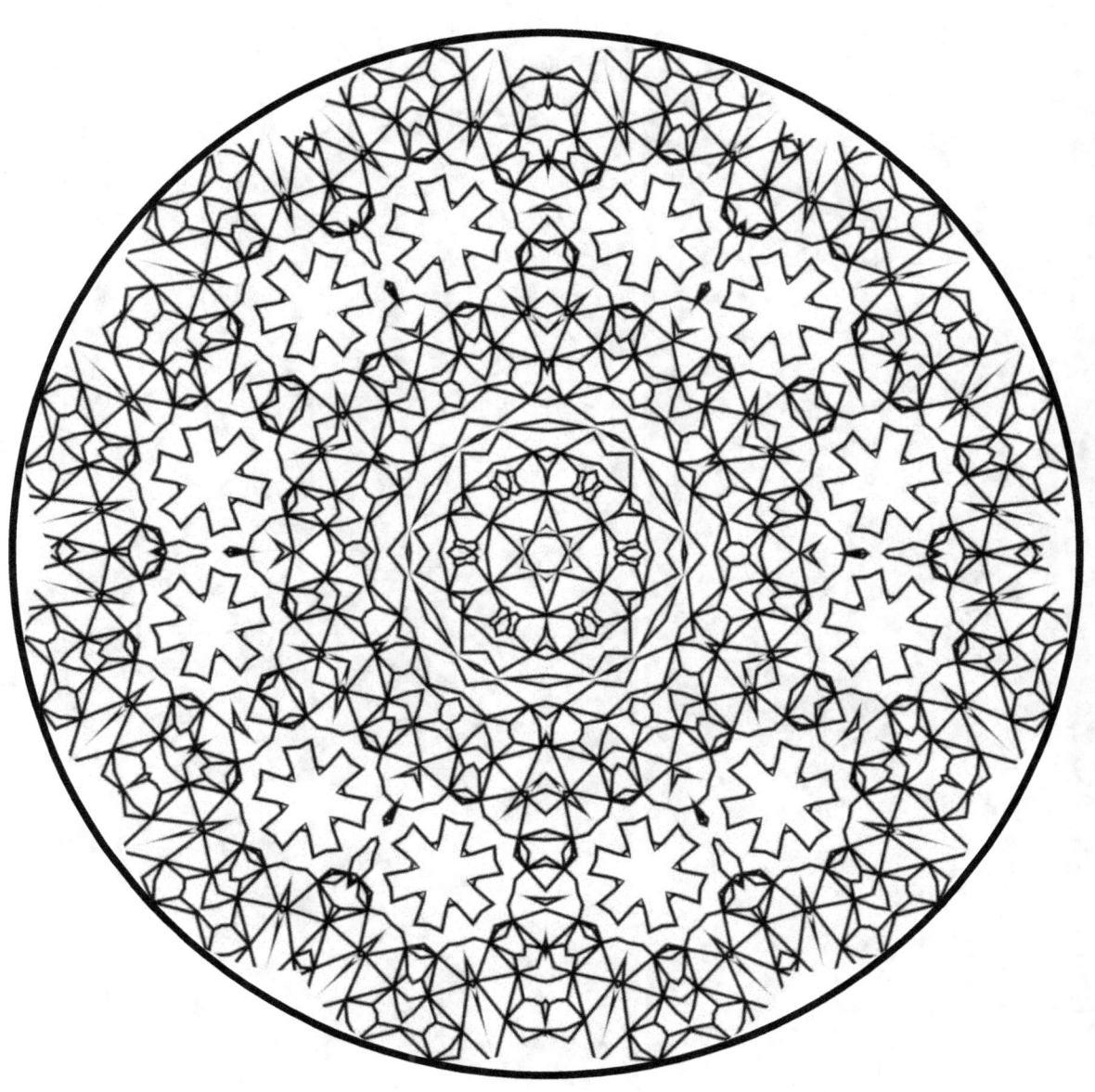

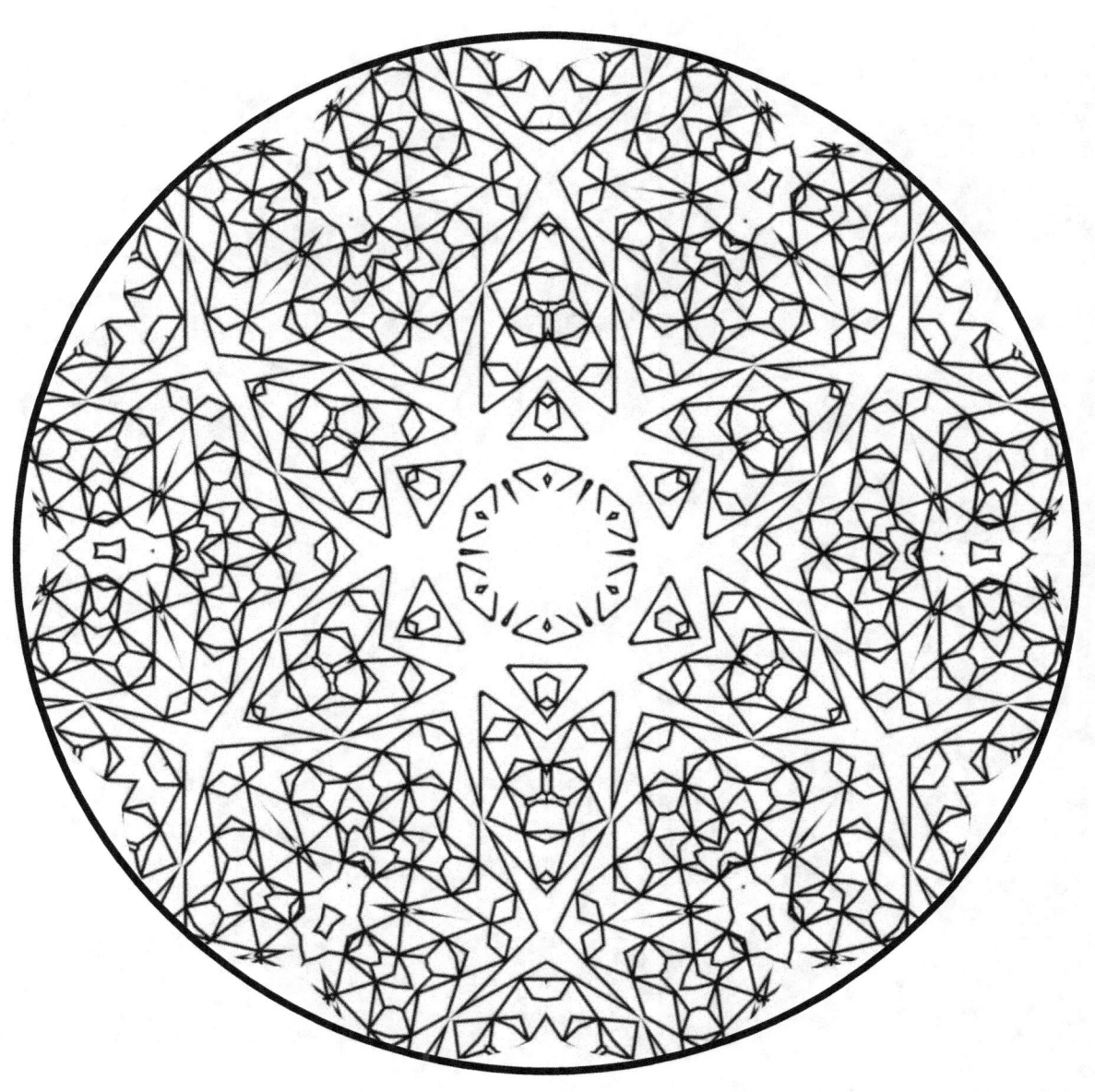

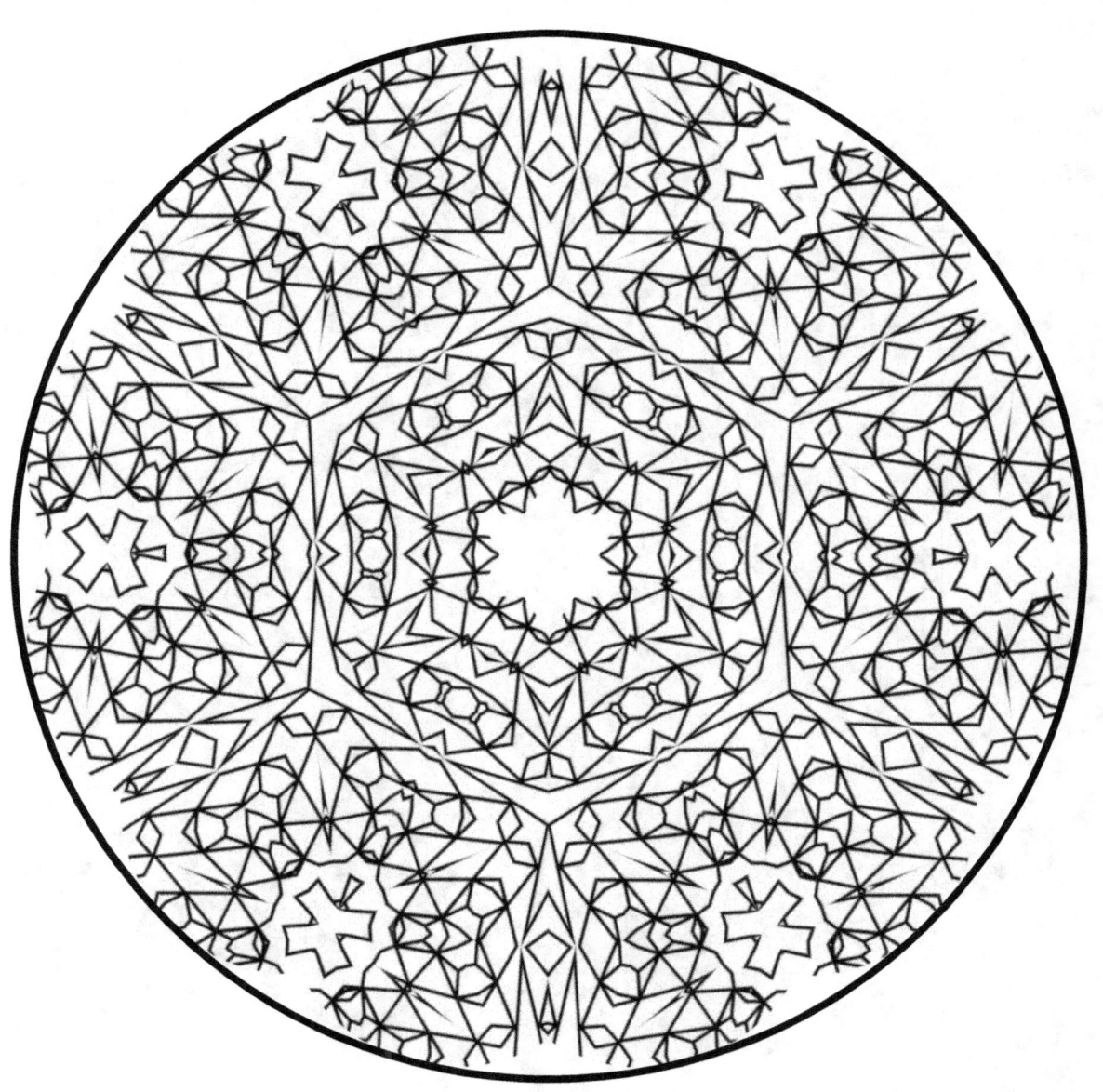

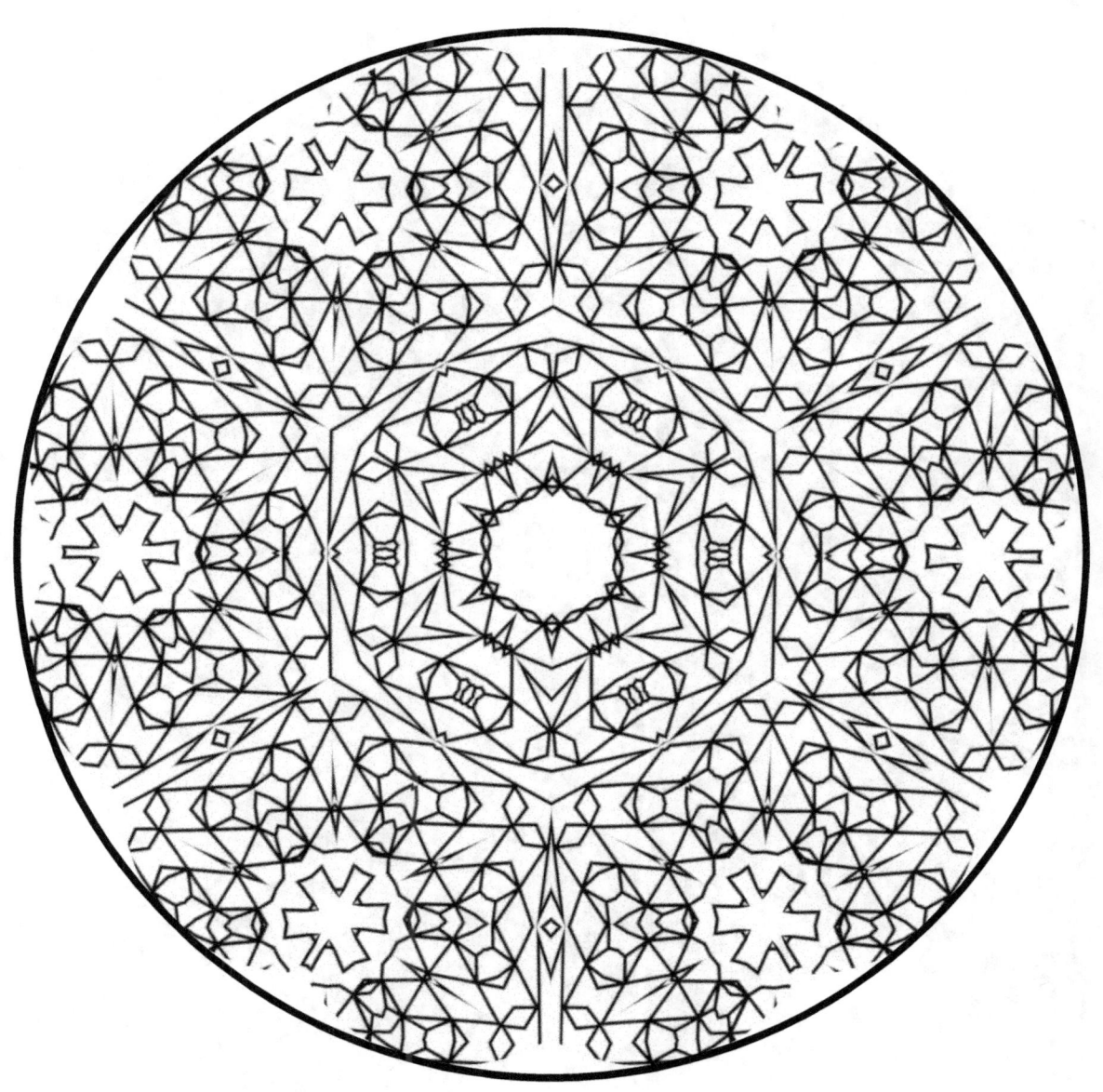

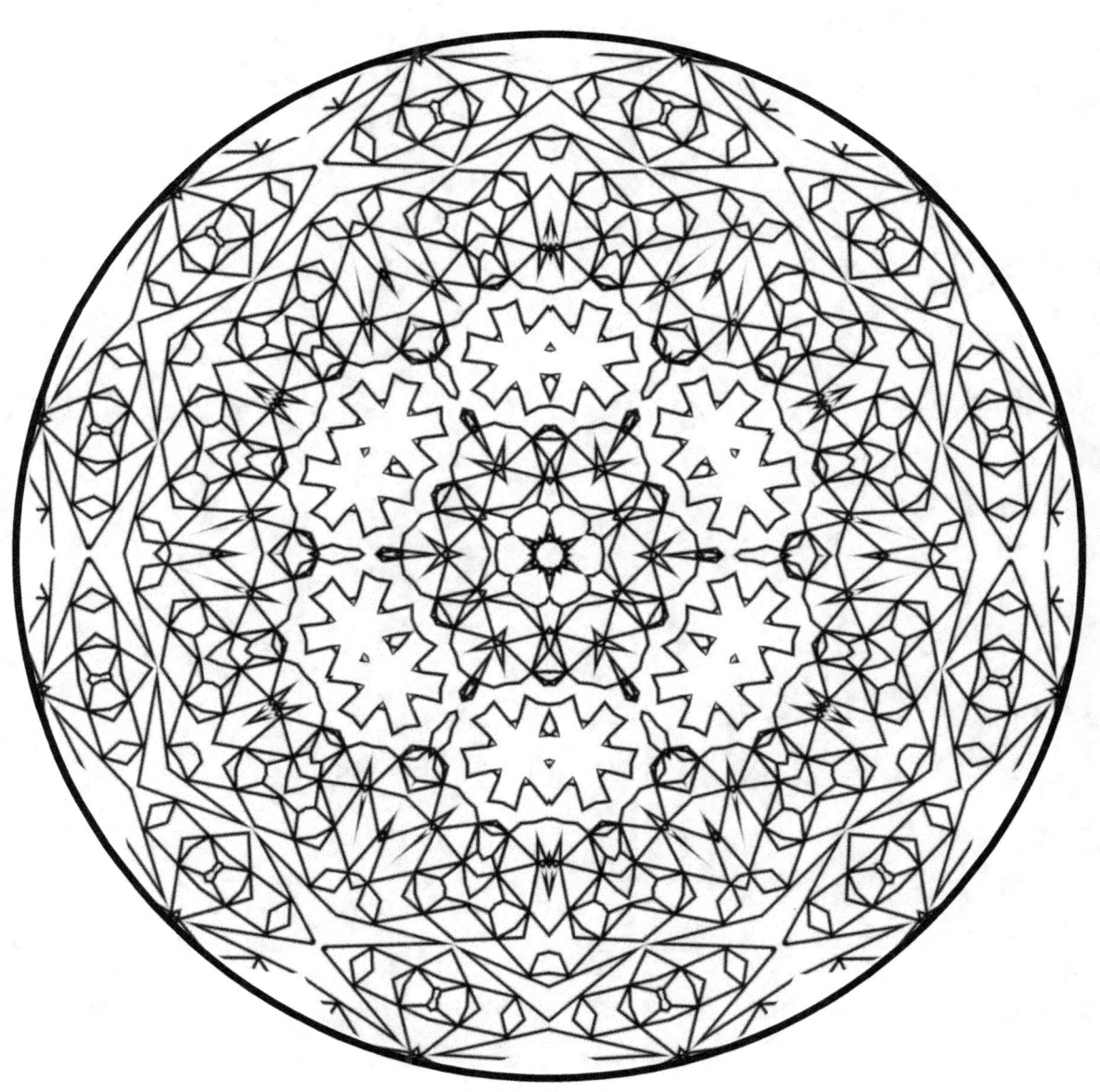

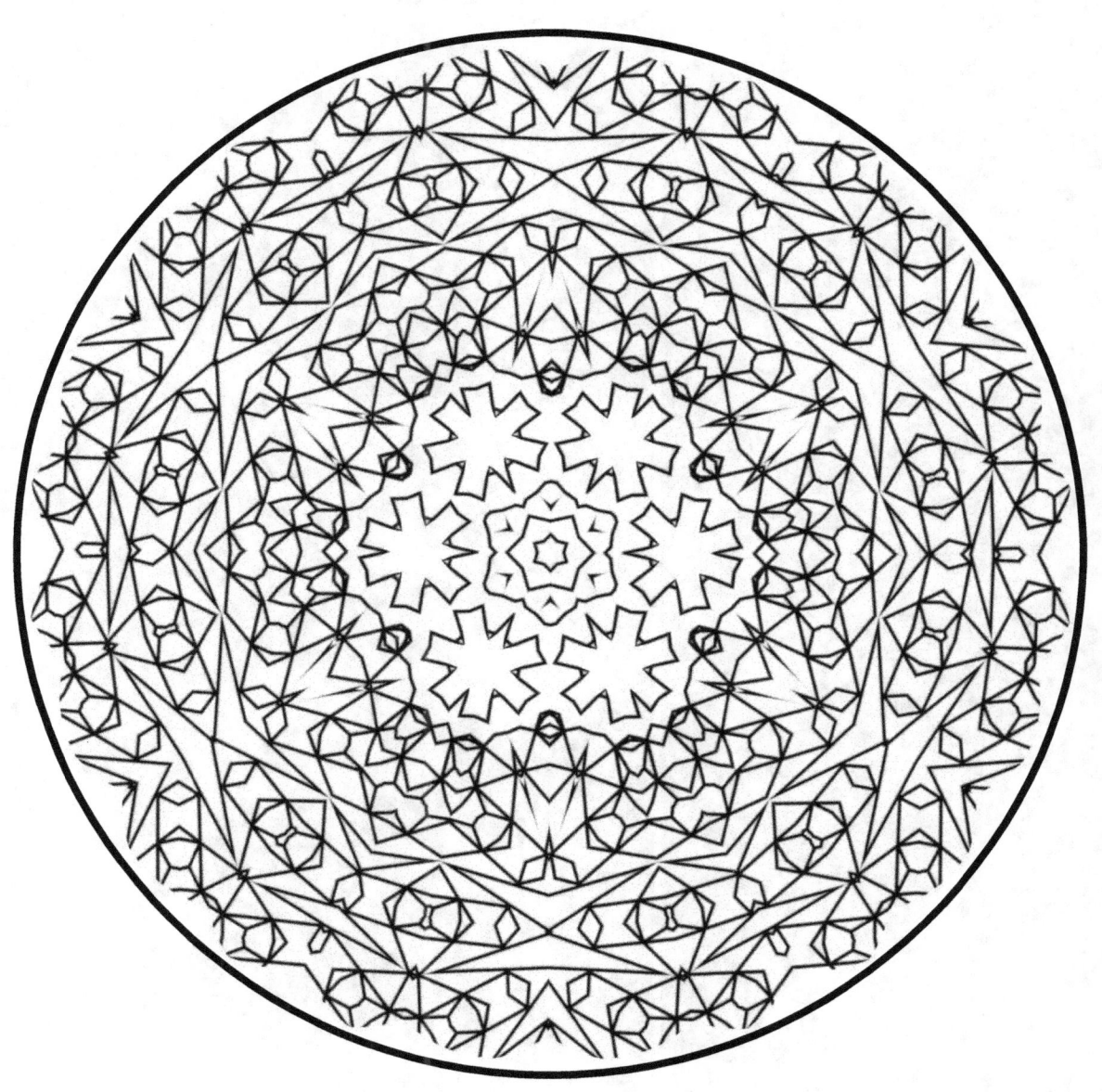

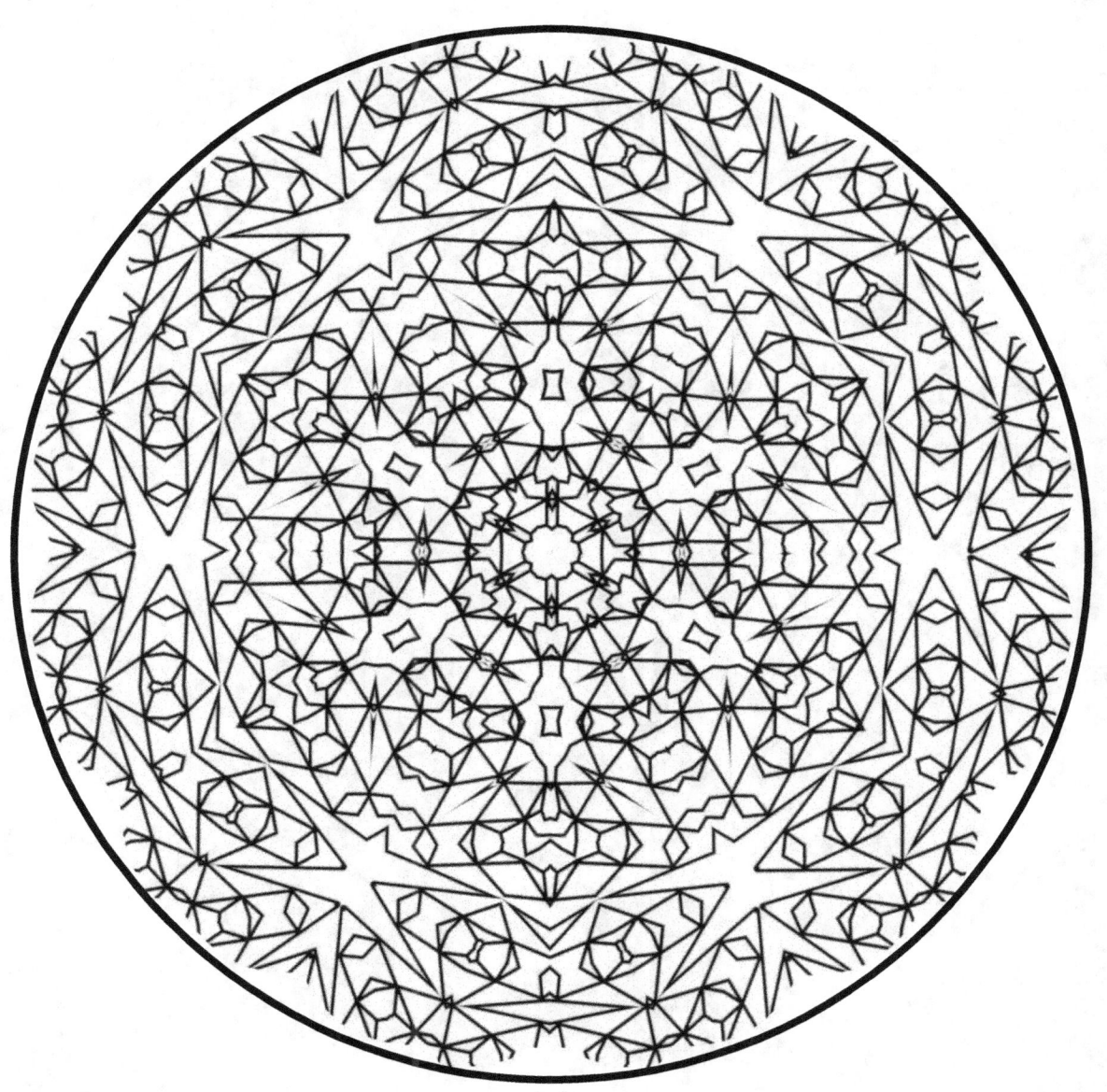

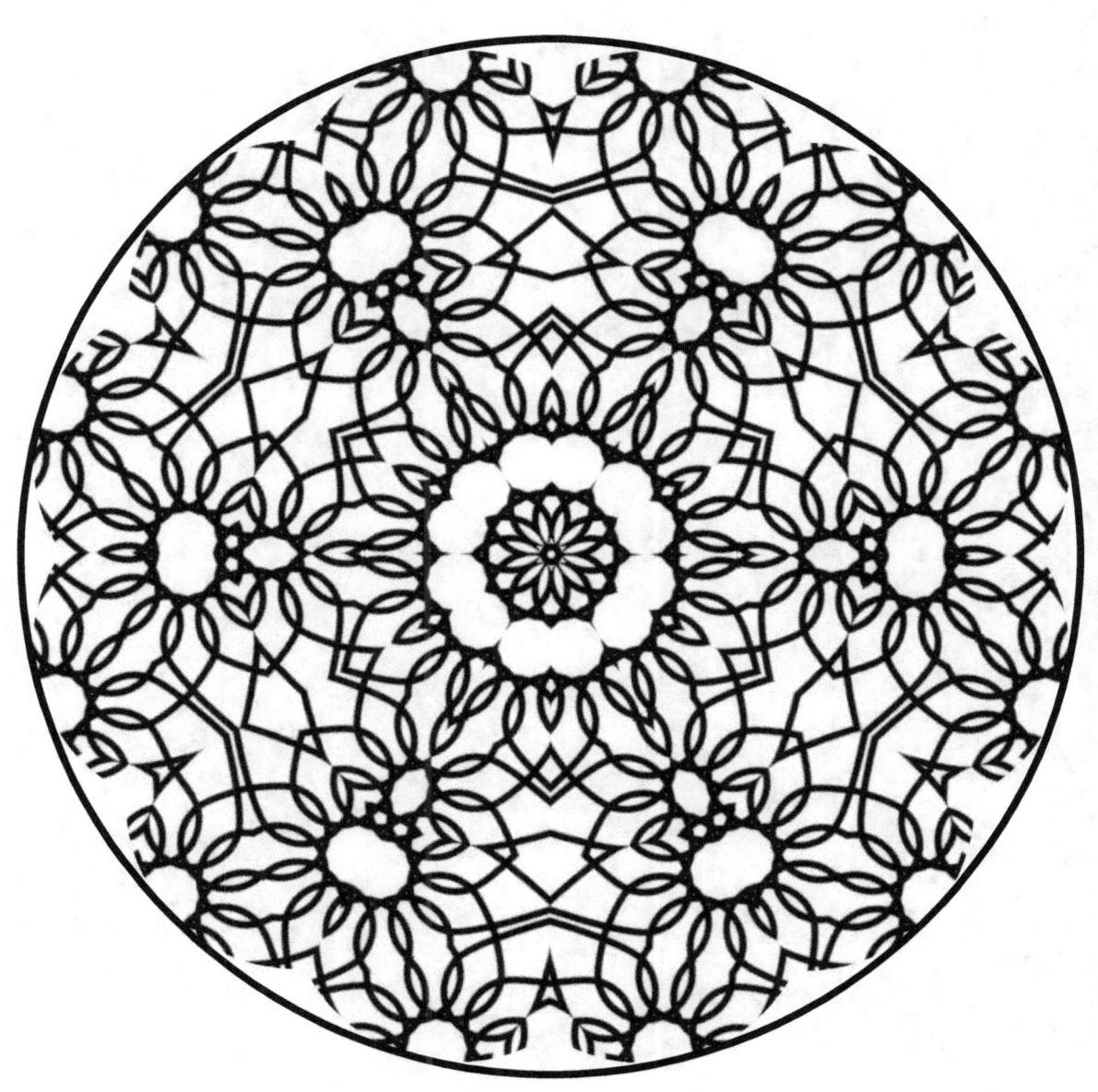

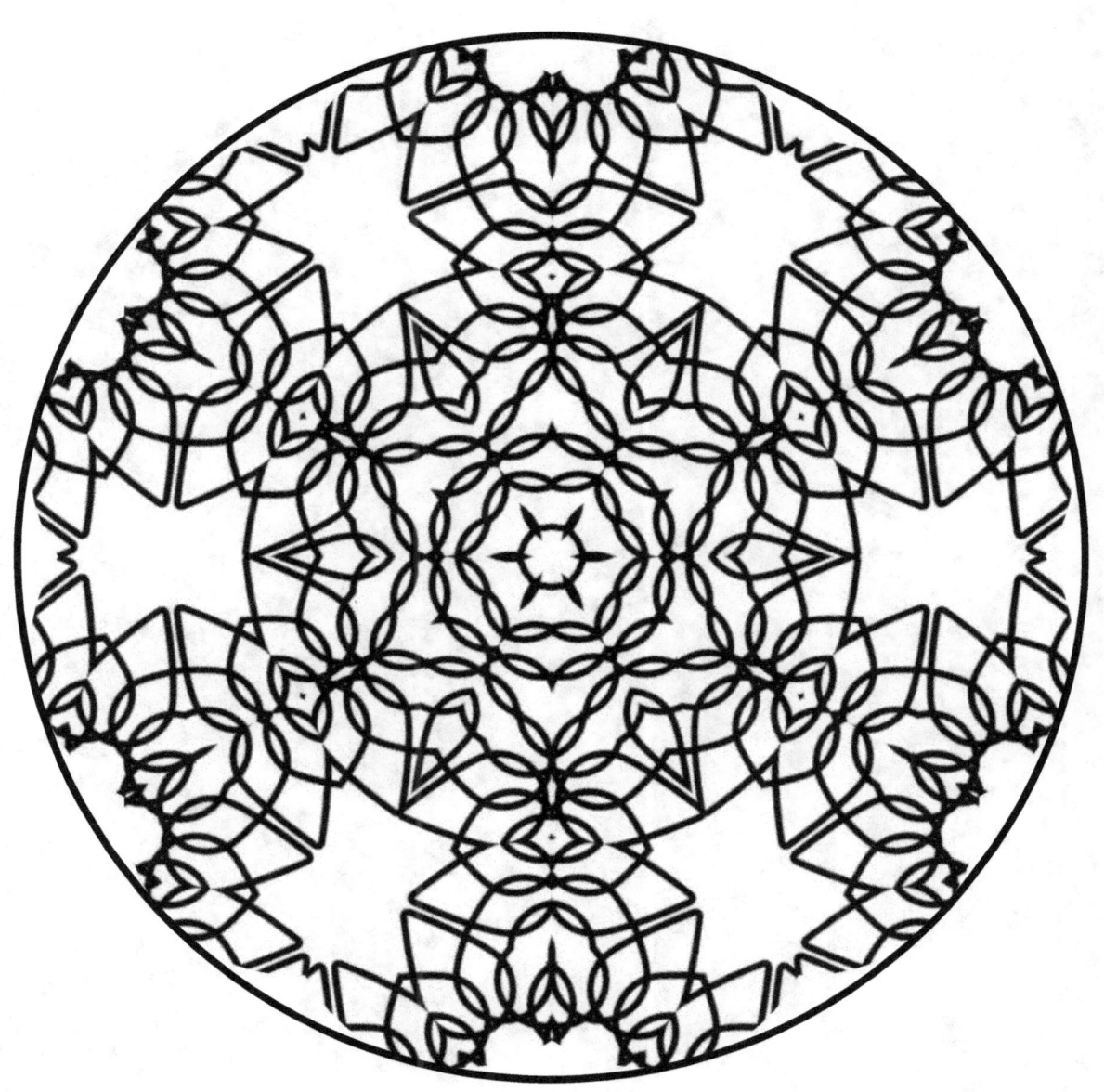

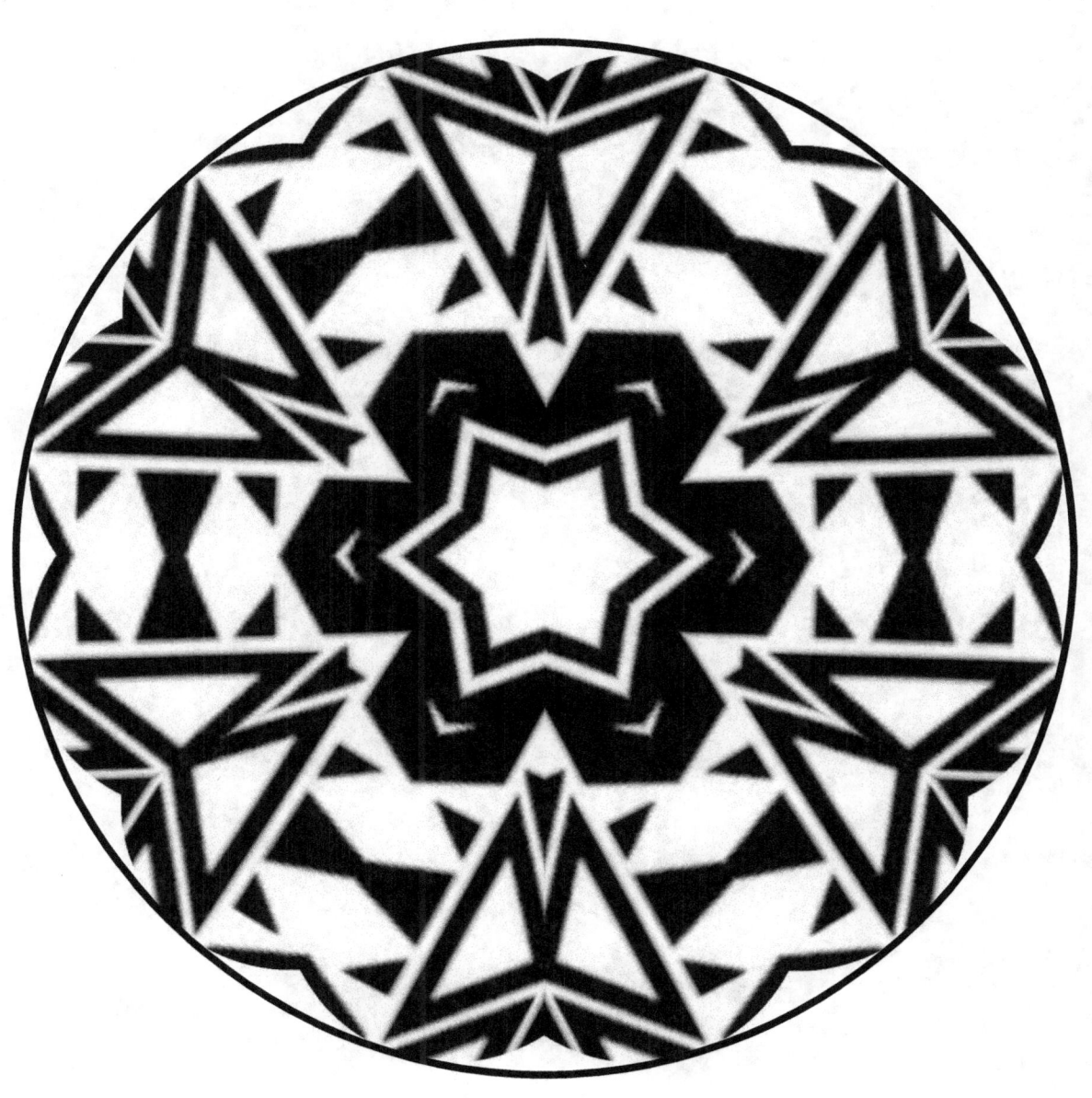

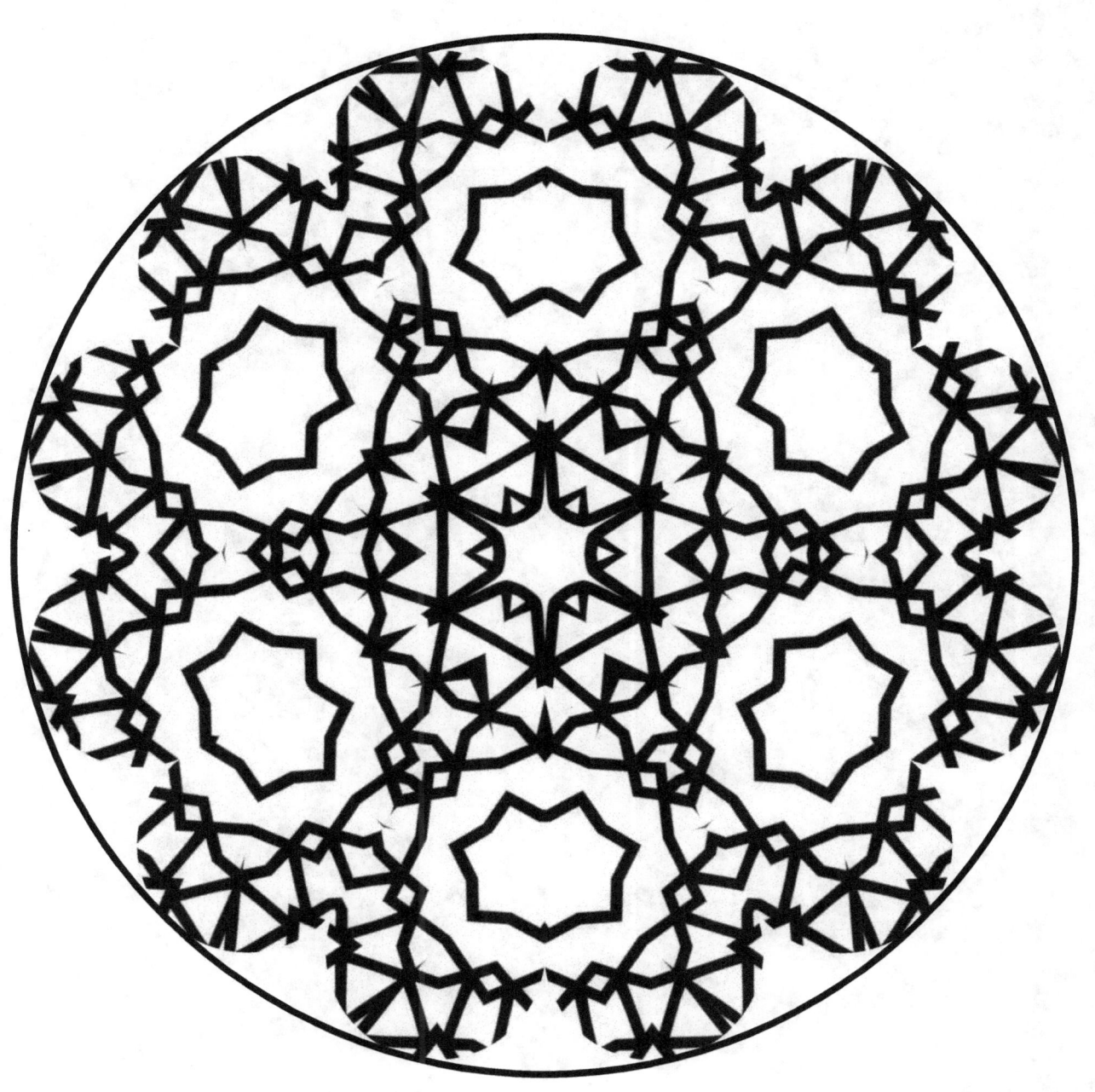

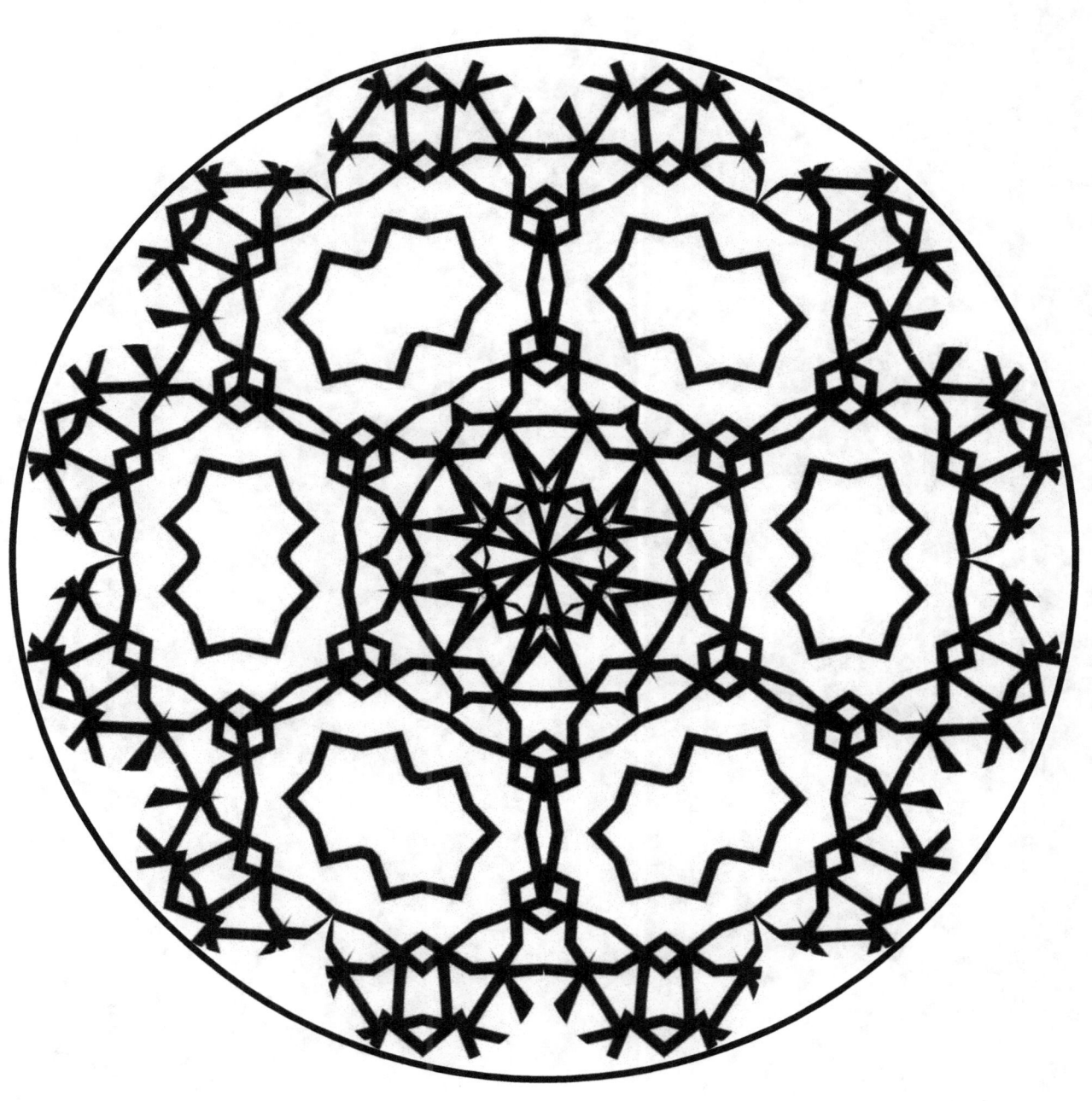

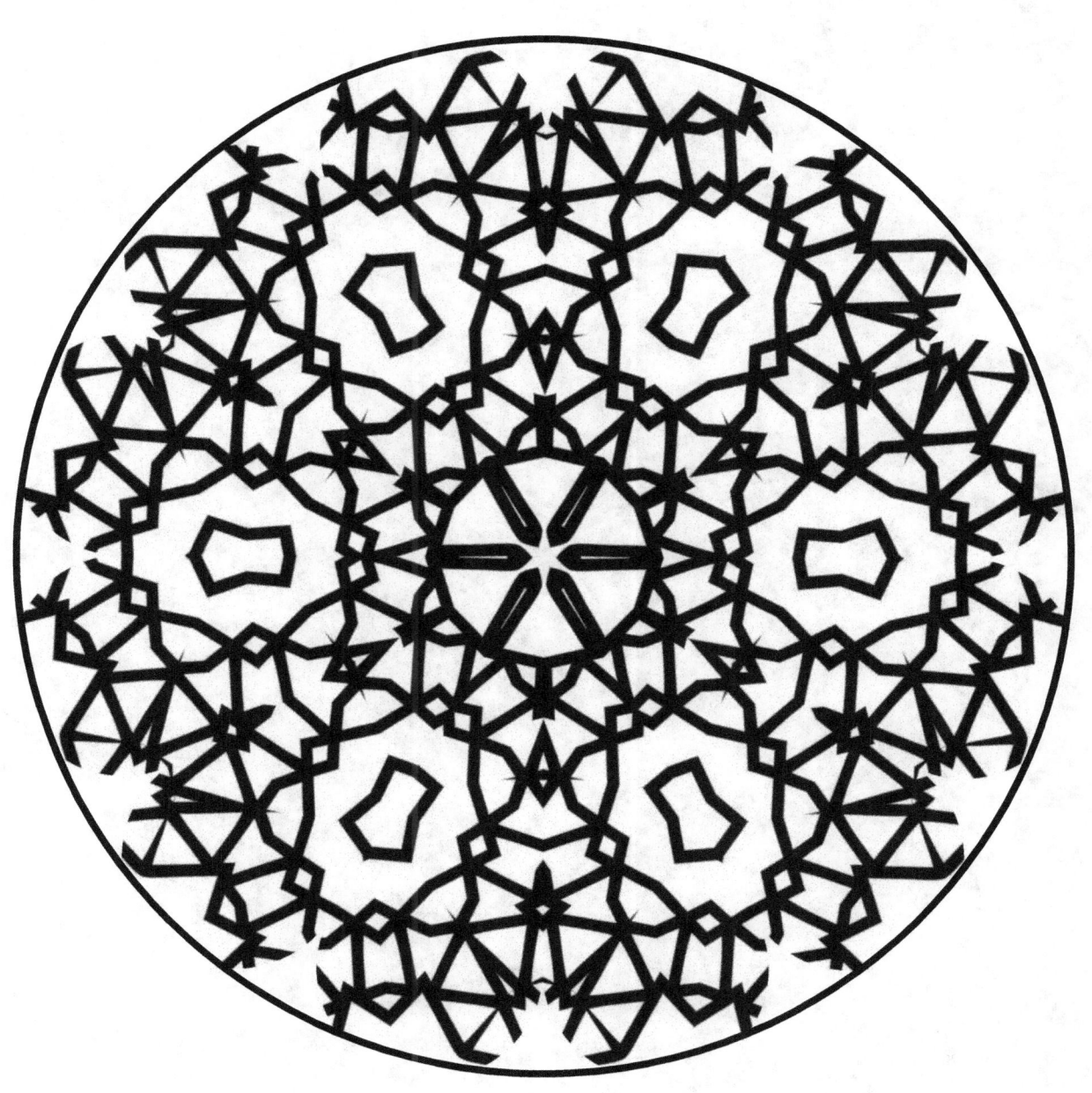

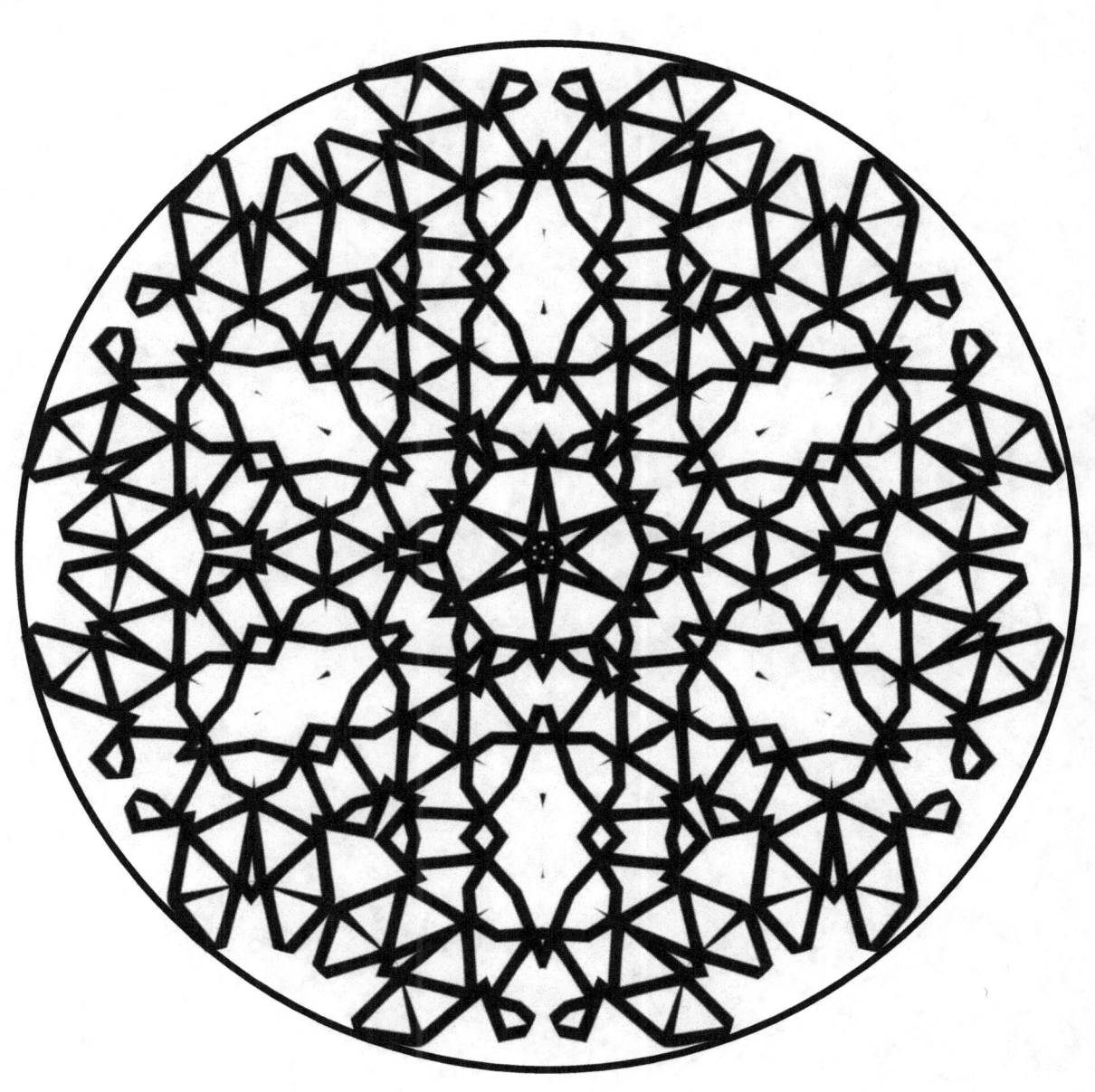

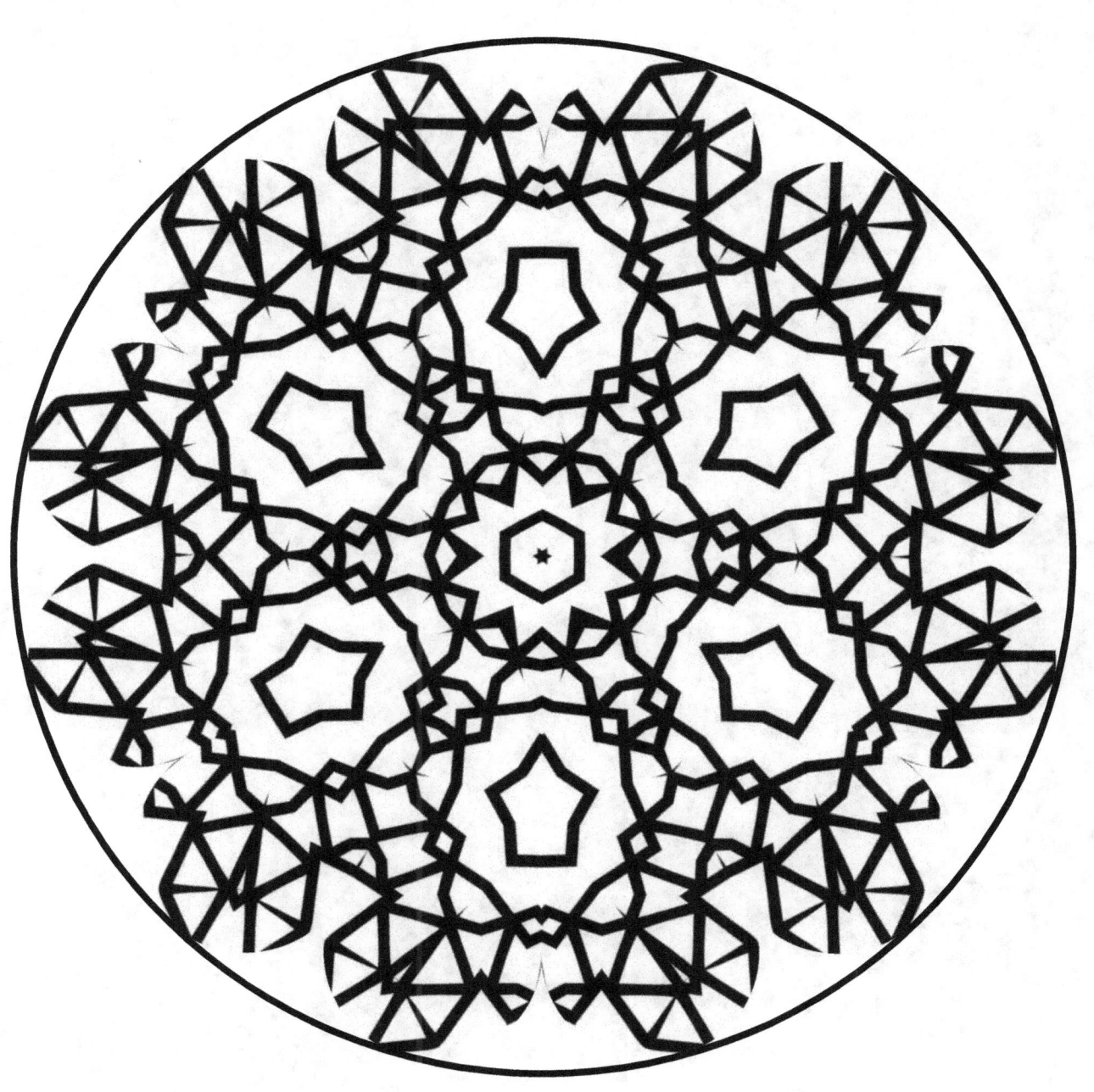

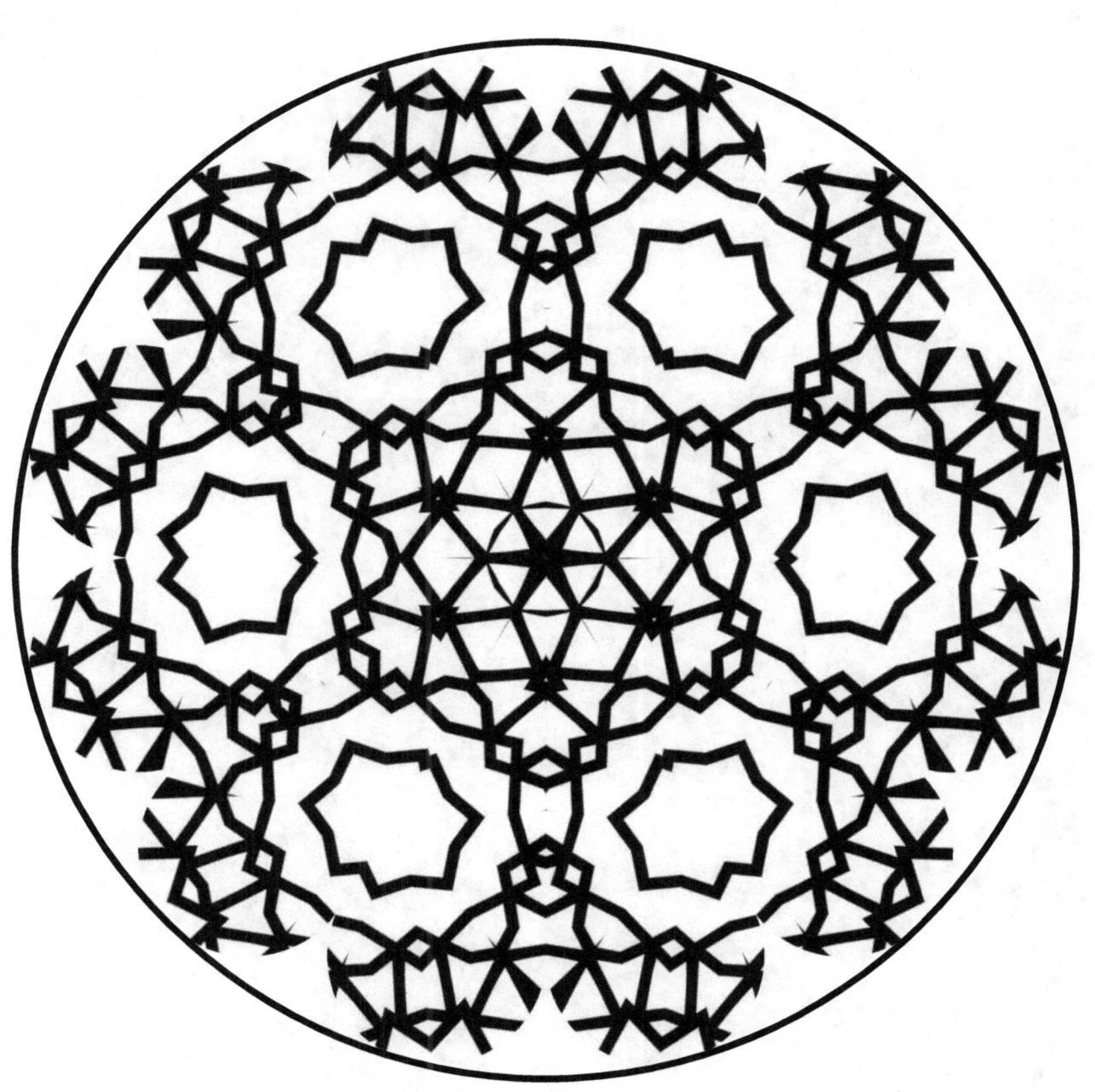

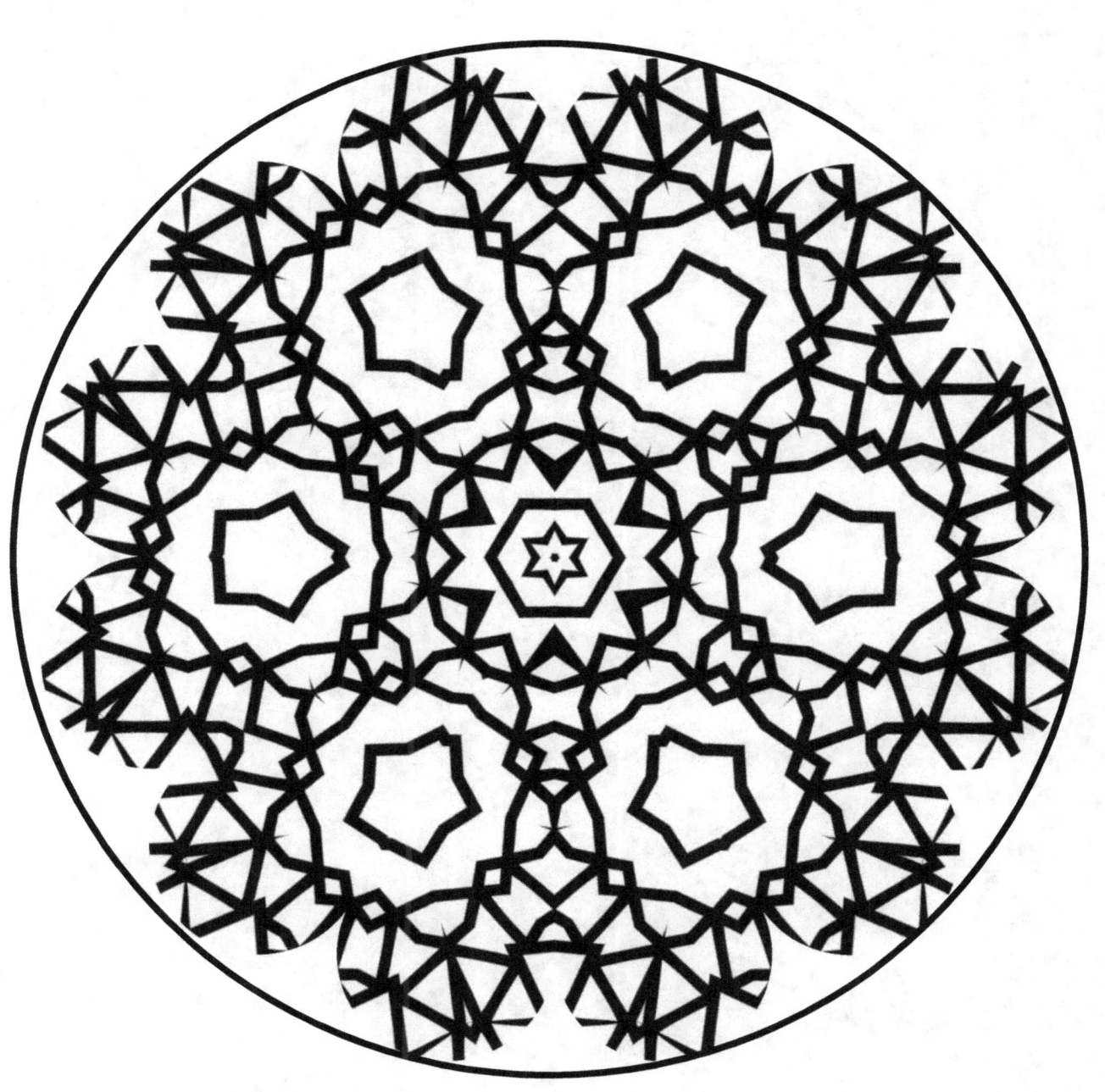

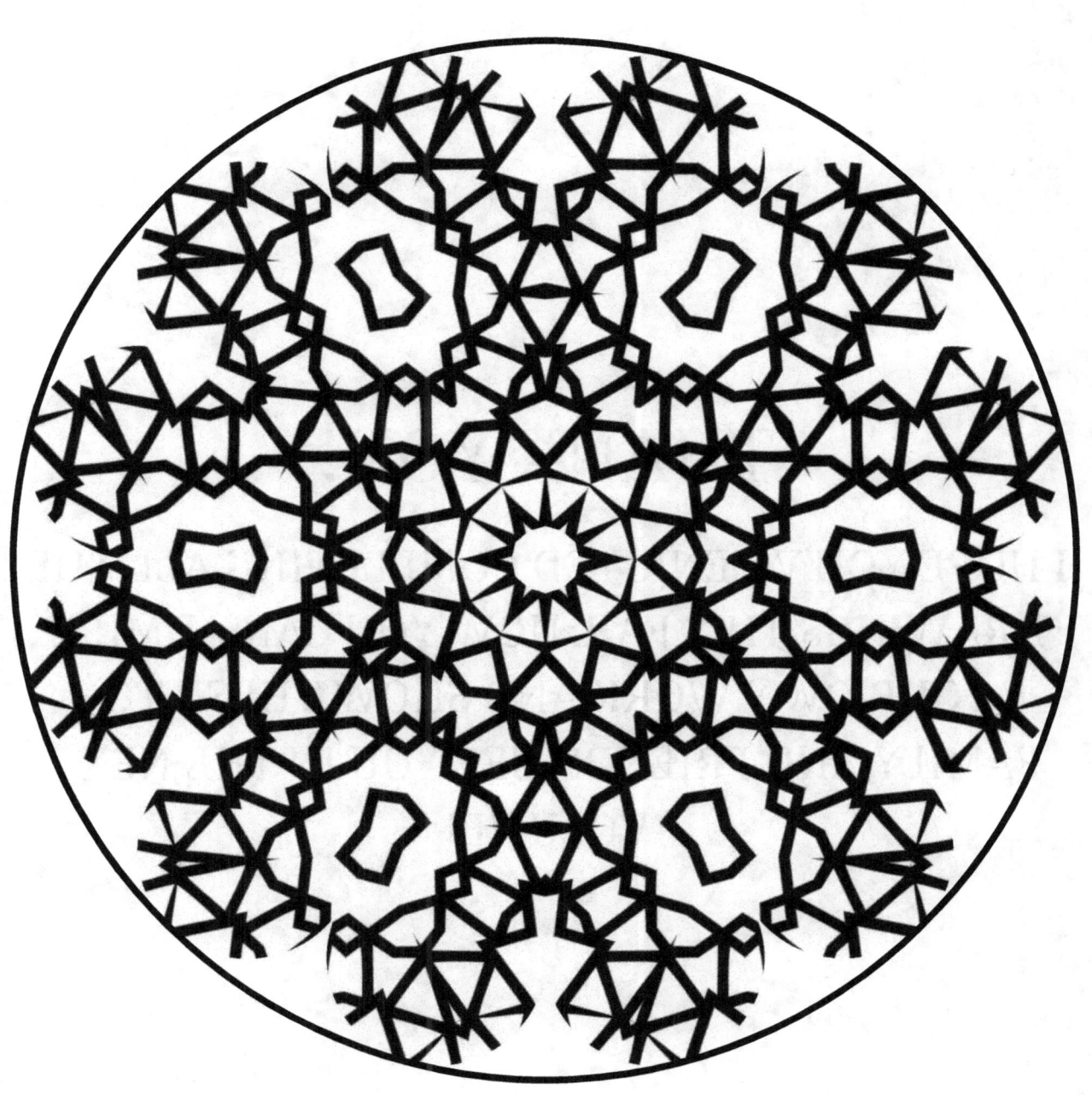

THANK YOU!

I HOPE YOU'VE ENJOYED COMPLETING ALL THE DRAWINGS THIS FAR. NOW YOU CAN ADMIRE YOUR OWN WORK AND SHOW THESE TO FAMILY AND FRIENDS. SEE YOU IN THE NEXT VOLUME!

www.ingramcontent.com/pod-product-compliance
Lightning Source LLC
Chambersburg PA
CBHW081159180526
45170CB00006B/2148